NORTH WEST CANALS

Manchester, Irwell & the Peaks

THROUGH TIME

Ray Shill

AMBERLEY PUBLISHING

First published 2013

Amberley Publishing
The Hill, Stroud, Gloucestershire, GL5 4EP
www.amberley-books.com

Copyright © Ray Shill, 2013

The right of Ray Shill to be identified as the
Author of this work has been asserted in accordance with
the Copyrights, Designs and Patents Act 1988.

ISBN 978 1 4456 1894 4 (print)
ISBN 978 1 4456 1906 4 (ebook)

British Library Cataloguing in Publication Data.
A catalogue record for this book is available from the
British Library.

Typesetting by Amberley Publishing.
Printed in Great Britain.

Contents

Introduction

There is a wealth of waterway heritage in the North of England that began with the making of rivers navigable. From time to time, these navigations were improved upon with the making of artificial cuts to bypass bends and shallow sections of the river; skills were then developed for constructing longer artificial waterways, or canals, as they became better known.

Such skills were already available to the millwright, who not only built watermills, but had to adapt a suitable water supply. Fast-flowing rivers with a constant supply of water required minimum infrastructure to drive the mill waterwheel, but it became a basic millwright skill to improve water supply for the mill, through the building of dams and making of millpools, diverting river channels and cutting leats to take water into the pool and then carry it away back to the main river course.

James Brindley was a millwright who no doubt drew on such skills and honed them for making canals. His professional involvement with canal engineering progressed when the Duke of Bridgewater chose his services for a new canal scheme from his mines at Worsley to Manchester. The inspiration for the Duke's venture is often quoted as being derived from the existing canals he visited in France. Whether directly or indirectly, the canal to Worsley was also probably influenced by the making of the Sankey Brook Navigation, which preceded the Duke's scheme. Both waterways drew on available water supplies. Those that followed required careful management of water and the building of reservoirs of sufficient capacity to supply them. They also adopted the concept of the canal descending from a watershed where water was available. Quite often, streams and rivers were not an option as the supply was jealously guarded by the mill owners. There were exceptions, however. The Leeds & Liverpool Canal Company, for example, acquired the River Douglas Navigation, and this river supply was used to feed their canal near Parbold and the deep lock at Apperly.

Such schemes provided the start of navigations in the North West, and from these beginnings a network of waterways was built, not only to serve local industry, but also to act as part of a chain of waterways that improved the transport of goods across the Pennines to Huddersfield, Leeds and York, and also forged links to the Midlands and the South East. Prior to the making of a national railway network, some of these waterways also conveyed passengers by packet boats.

It is the legacy of these times that waterways still survive through Manchester, the Peak District and north to the Lake District, many of which are still enjoyed by the boater, walker or cyclist.

Chapter One
River Navigations &
the First Canal to Manchester

River Irwell, River Mersey and the Bridgewater Canal

The Mersey was an important navigation. Tidal limits reached Warrington, but required locks beyond there for craft to travel towards Manchester. This combined Mersey and Irwell Navigation, and reached Salford and the rocky cliff on the Manchester side of the Irwell, which had parts cut away for wharves.

Navigation to Manchester was first proposed in 1660, but was not proceeded with at that time. Dock and canal engineer Thomas Steers revived this scheme during 1712, yet the task of making the rivers navigable was delayed for twenty-four years. It took another eight years to present the bill to Parliament, and while the Act was passed in 1721, construction work did not begin for the Mersey & Irwell Navigation Company until 1724. The making of eight locks required another twelve years (1736), although craft could reach the quay at Manchester by 1734. This navigation was gradually improved, and at one time had eleven locks with some canal sections on the western part (discussed in the previous volume covering Merseyside, Weaver and Chester).

The first canals made in the North West included the Sankey Brook Navigation and the Bridgewater. The first section of the Bridgewater to be built ran from Castlefields to Worsley and served the underground mines there. This section was lockless but involved a crossing of the Irwell at Barton by an aqueduct. The Bridgewater was then extended to Runcorn and formed a link also with the Trent & Mersey Canal at Preston Brook.

Sponsored and supported by the Duke of Bridgewater, the Bridgewater Canal was the first artificial waterway to reach Manchester. While construction began on the extension to Runcorn, plans were made to link the Bridgewater with other projected routes to link with the River Severn and the River Trent. Such plans may never have materialised if John Golborne's survey for the Macclesfield Canal had been accepted. While the bill for the Macclesfield Canal was delayed in the House of Lords, the bill for Brindley's Trent & Mersey and Staffordshire & Worcestershire canals passed through unhindered, becoming Acts of Parliament.

The Trustees of the Duke of Bridgewater controlled the operation of the Bridgewater Canal, and from 1846 they also acquired control of the Mersey & Irwell Navigation. The Irwell in Manchester was navigable to the Quays and was linked to other waterways there, the first being the Manchester Bolton & Bury Canal, which was a barge-width waterway (*see Chapter 2*).

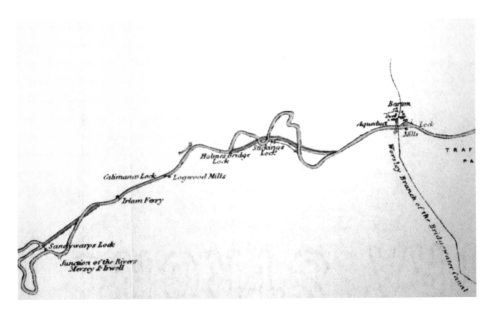

Palmer's Plan for a Ship Canal to Manchester, Mersey & Irwell Navigation, 1840
Nearly fifty years before the Manchester Ship Canal construction began, plans were put forward for a ship canal to Manchester. From Warrington, further cuts were proposed. The intended line (not built) is shown in red, yet this plan also shows the location of the locks that were made. Original locks at Sandywarps, Calimanco, Holmes Bridge, Stickings and Barton Locks are shown in this upper illustration. The lower map shows the terminus and the remaining locks of Mode Wheel and Throstles Nest on the Irwell to the Manchester & Salford Wharves. (*Heartland Press Collection 786021 & 786022*)

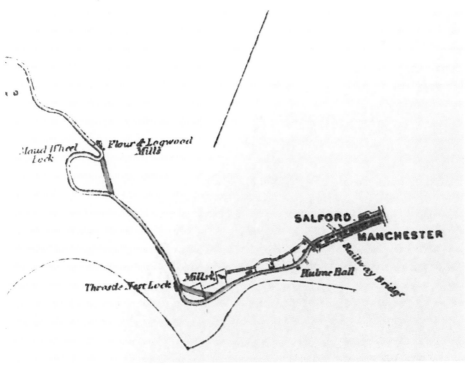

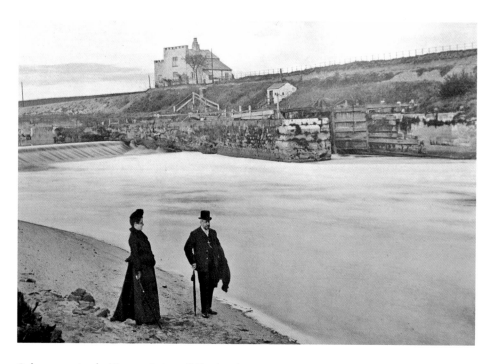

Calamanco Lock, Mersey & Irwell Navigation
Calamanco Lock was one of the locks of the navigation, but was removed in 1883 before the
Manchester Ship Canal scheme was proposed. (*Heartland Press Collection 786041*)

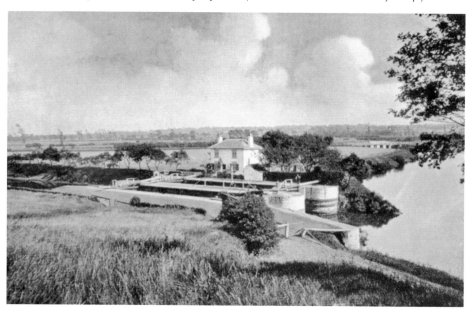

Butcherfield Lock and Cut, Mersey & Irwell Navigation
The navigation from the Mersey had artificial cuts from Runcorn to Latchford, and the
Walton Cut, which enabled craft to pass beyond Warrington. The next lock that cut east
of Walton was Butcherfield and after that was Sandywarps, which had a short lock cut to
avoid a bend in the river. (*RCHS Photograph Collection Ref. 40340*)

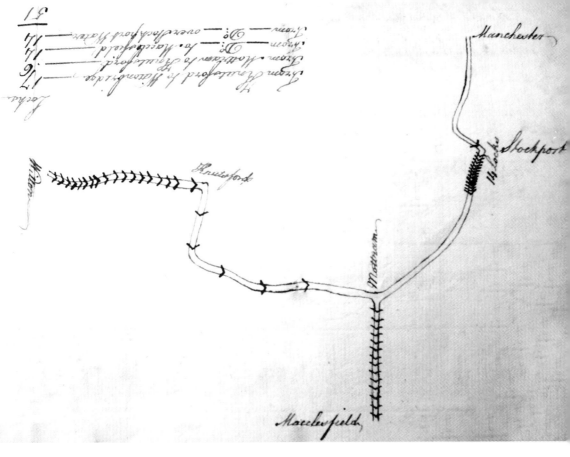

Proposed Macclesfield Canal

John Golborne was engineer for the canal from the River Weaver at Witton Bridge to Macclesfield and Manchester. The Act passed the House of Commons in 1766, but was blocked by the House of Lords after hearing evidence from James Brindley and taking note of the Duke of Bridgewater, whose canal it would have joined. This waterway required fifty-one locks, but would have served Macclesfield some sixty years before a canal was finally made there.

	Locks
From Knutsford to Witonbridge	17
From Mottram to Knutsford	6
From D?. to Macclesfield	14
From D?. over Stockport Water	14
	51

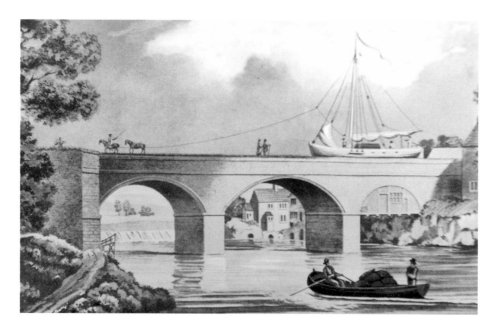

Barton Aqueduct, Bridgewater Canal

James Brindley was the engineer responsible for the design and construction of the Bridgewater Canal, which began in 1759. An initial proposal for a terminus on the Salford side of the River Irwell was changed in 1761, and the first section to be opened was between the Worsley coal mines and Stretford. This work included the three-arch Barton Aqueduct, which allowed working craft on the Bridgewater to look down upon the flats and other vessels on the Mersey & Irwell Navigation. (*Heartland Press Collection 785225*)

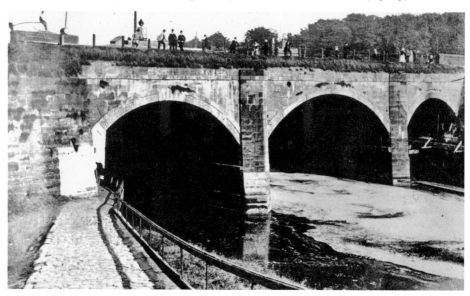

Barton Aqueduct, Bridgewater Canal

The canal aqueduct at Barton, prior to its demolition to make way for the ship canal. This aqueduct was completed in 1761 and spanned the Mersey & Irwell Navigation. Craft passed though the left-hand arch to reach the lock at Barton. (*RCHS Slide Collection 58578*)

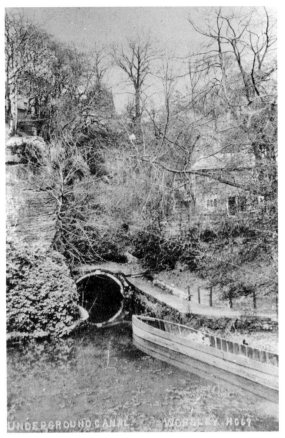

Worsley Mines, Bridgewater Canal
James Brindley's canal from Worsley to Manchester carried coal from the mines, which were accessed by a network of canal tunnels. The boats that served these were narrow in width and carried the coal in special containers that fitted into boats. Inclines existed in the mines that conveyed boats between levels. At Worsley there were two separate points of access to the mines. In the upper view, the right-hand entrance is visible, while in the lower view both entrances are seen. (*Above*: *RCHS Slide Collection 54581. Below: RCHS Hugh Compton Collection 64314*)

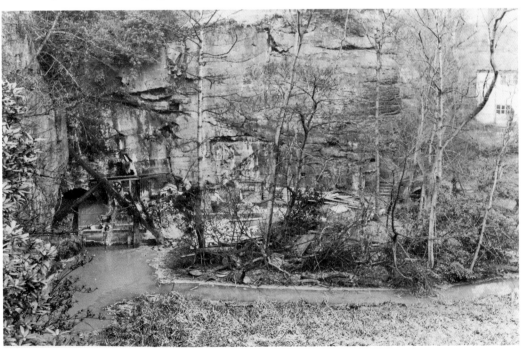

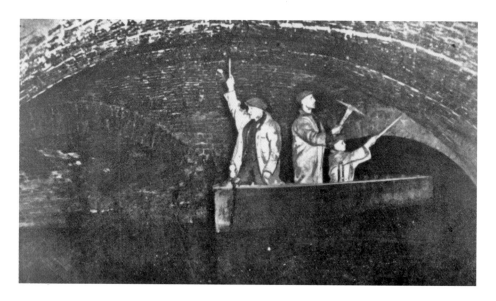

Worsley Mines Canals

The extensive system of underground canals existed principally on two levels, although there were two deeper, shorter levels connected by vertical shafts to the main and central levels. These canals were, on average, 10 feet wide, with 8 feet of headroom, and were between 2 feet 6 inches and 3 feet deep. They extended north from the Worsley Portal towards Bolton, with side branches and passing places. The main level made from Worsley was below the other principal level and was initially connected by a vertical shaft to the higher canal. From 1795, boats were able to access the higher level through an incline plane. (*Heartland Press Collection 785451*)

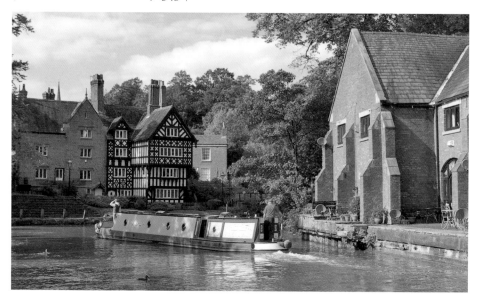

Worsley, Bridgewater Canal, 2010

While the mine's canal ceased to be used for transporting coal, it retained a use for drainage. The brown water is a result of the minerals dissolved in the supply, which still flows from the underground mines. (*Ray Shill 785421*)

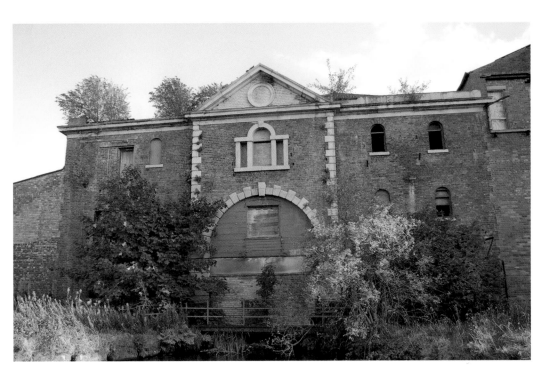

Warehouse, Broadheath, Near Sale, Bridgewater Canal
A survivor from the carrying days of the Bridgewater Trustees is the Broadheath Warehouse (1833), which remains beside the waterway. (*Ray Shill 784281*)

Burford Lane Underbridge (25A), Near Lymm, Bridgewater Canal, 2009
On the Bridgewater Canal, aqueducts over roads were referred to as underbridges. This road gave access to the nearby canal warehouse. (*Ray Shill 783760*)

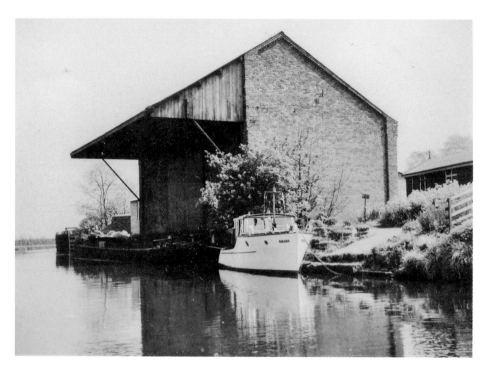

Lymm Warehouse and Lymm Bridge, Bridgewater Canal
The Cheshire town of Lymm provided a useful interchange point between the canal and road network. The warehouse there was both small and simple in construction, unlike the larger buildings at nearby Burford Lane. (*Above: RCHS Hugh Compton Collection 64269. Below: RCHS Hugh Compton Collection 64270*)

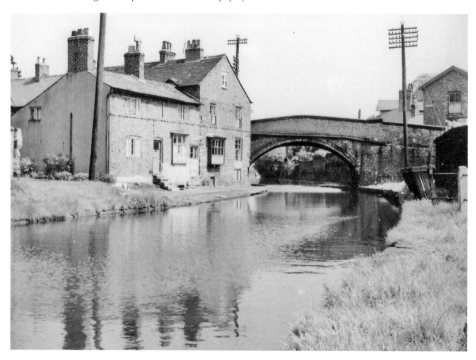

Lymm Aqueduct and Lymm Bridge, Bridgewater Canal, 2009
The canal passes close to the centre of Lymm, where public roads pass under and over the waterway. Whitbarrow Underbridge passes under the canal, and within a short distance Lymm Bridge crosses over the canal. (*Above: Ray Shill 783725. Below: 783733*)

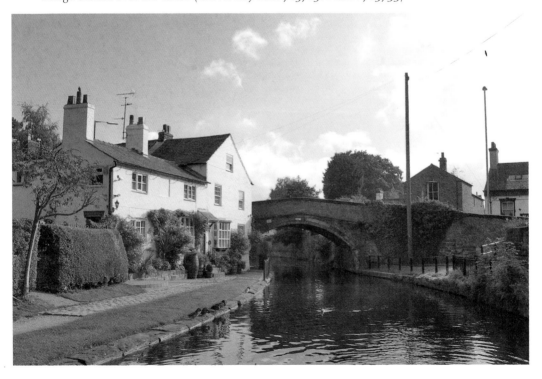

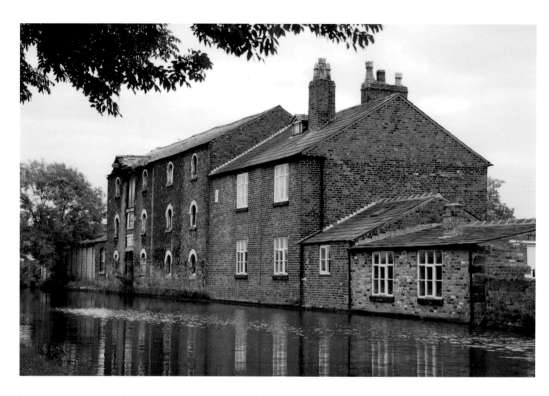

Warrington Lane Warehouse Near Lymm, Bridgewater Canal, 2009
This three-storey warehouse resembles those at Castlefield. (*Above: Ray Shill 783765. Below: Ray Shill 783768*)

Chapter Two
Linking Canals & Rivers

Ashton, Bridgewater (Leigh Branch), Bridgewater (Hulme Locks), Fletchers, Lancaster, Manchester Bolton & Bury, Manchester & Salford Junction and Peak Forest

Once the initial group of canals had been made, fresh schemes were put forward for other waterways. The Ashton and Peak Forest formed connecting waterways from Manchester to the lime quarries terminus at Bugsworth and the mill town terminus at Whaley Bridge. Both were narrow waterways, their locks being only wide enough for narrowboats to pass.

Completing the Ashton Canal also required the making of a junction with the Rochdale Canal, which was a barge, or broad, waterway. The canal from Ancoats to Ashton was opened during 1796, but the remainder from Ancoats to Piccadilly was finished in 1799 and the link with the Rochdale was evidently made a year later. There were several branches that linked with the main Ashton Canal, which served local industry. The longest of these were the Hollinwood ($4\frac{5}{8}$ miles) and Stockport ($4\frac{7}{8}$ miles). The shortest perhaps of any British canal branch was the Dukinfield, which was around 40 yards long and principally comprised an aqueduct over the River Tame to join up with the Peak Forest Canal at Dukinfield Junction.

Hollinwood passed through Waterhouses, where the Fairbottom Branch diverged and terminated at the junction with the private Werneth Canal to Old Lane Colliery. This private branch was also the feeder that brought water on the Ashton Canal.

The Peak Forest Canal was never completed to the intended terminus at Chapel Milton, where the limestone quarries had the potential to provide important traffic for the canal. It joined the Ashton at Dukinfield and climbed up through sixteen locks to the summit at Marple, continuing on from there along a level section to Bugsworth (Buxworth). This section of the canal, including the locks, was finished in 1804. From Bugsworth, the canal was intended to be raised to Chapel Milton with additional locks, but it was decided to build this section as a plateway laid on stone blocks. This plateway was used to carry the limestone to Bugsworth where trans-shipment basins were provided. A branch from the main route near Bugsworth terminated at Whaley Bridge, where water from Toddbrook Reservoir entered the canal. From 1831, this also served as the northern terminus of the Cromford & High Peak Railway.

Benjamin Outram was engineer for the Peak Forest Canal until 1801; he was also engineer for the Huddersfield (Narrow), which joined the Ashton and rose by thirty-two locks to Diggle, passed through a 3-mile 176-yard tunnel at Standedge to Marsden, and then descended by forty-two locks to Huddersfield.

Totally separate from the canal network was the Compstall Navigation, which was a canal or channel that brought water from two reservoirs to mills at Compstall Bridge. As well as a water supply, this channel was in the mid-nineteenth century used to move coal in boats.

The Lancaster was a waterway that was intended to link the coal mining areas near Wigan with Preston and Lancaster, and as first planned would have started near Westhoughton. The

route changed during the construction period and became a canal of two halves (the South Lancaster and the North Lancaster), which was joined in the middle by a plateway laid on stone blocks. While images of the Lancaster Canal Tramroad and the North Lancaster will be left for a future book, the South Lancaster will be included here as its route and operation became closely associated with the Leeds & Liverpool Canal.

Contractors worked on various sections of the waterway at the same time. The South Lancaster started at Bark Hill and passed through Adlington and Chorley to Walton Summit where the tramroad started. This section was opened in 1803, and by 1804 was carrying coal from pits in the Wigan area, including Orrel and Wynstanley, which were served by the Douglas Navigation and would have sent out coal to Lancaster and Preston using the coastal route. With the completion of the Lancaster Canal, an inland route was made available.

Bolton and Bury were linked to Manchester through a barge canal that descended through the valley of the Irwell to link up with the navigable part of the Irwell and the benefits it brought with the navigation through to the Port of Liverpool. The summit level was fed by a reservoir near Bury, which was supplied by a 3-mile-long channel that took water from the Irwell. This summit comprised two separate branches of the canal: one to a terminus at Bury, the other to another terminus at Bolton. They met at Nob End, where locks took the canal down to the aqueduct crossing of the Irwell at Prestolee.

Fletcher's Canal was a narrow waterway used by narrowboats that handled traffic for Matthew Fletcher's collieries near Clifton. Part of the channel was cut for James Brindley in the 1750s to carry water from the Irwell to drive a waterwheel for draining the mines at Wet Earth. Fletcher arranged for the widening of the channel (1790/91) so that it could also be used for navigation of coal. The canal came close to the Manchester Bolton & Bury Canal, but did not join it when that canal was made from Salford. A single large lock was eventually made to form a junction.

Two major links were made to the Irwell during the 1830s. The first joined the Rochdale with the Irwell at a point almost opposite the entrance to the Manchester Bolton & Bury Canal. This was the Manchester & Salford Junction Canal, which had four locks along its route. Traffic never reached its expected potential and the top half became disused. Nearby, a link was also made to the Bridgewater via three locks at Hulme. Contractors spent eighteen months building this short link, but it was a link that was used by craft accessing the wharves on the Irwell as well as the subsequent ship canal.

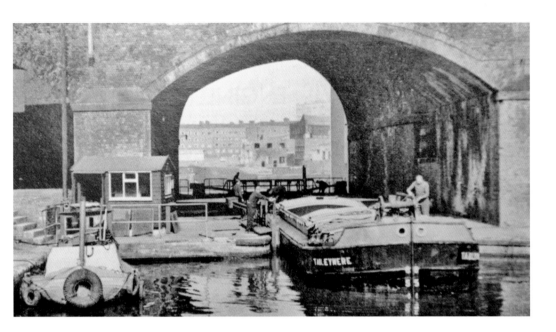

Hulme Locks, Bridgewater Canal

During 1838, the Bridgewater Canal was linked by three locks to the River Irwell, forming a connection for flats to pass between the two navigations. This connection was maintained after the ship canal was opened, as the top end of the Irwell Navigation was unaffected. Craft could also pass between the Bridgewater and the Manchester Bolton & Bury Canal by this route. (*Above: Heartland Press Collection 785101. Below: Ray Shill 785105*)

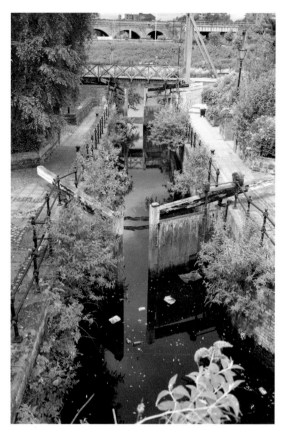

Bottom Lock, Manchester & Salford Junction Canal, Manchester
Opened a year later than the Hulme Lock link to the Irwell, the junction canal connected the Rochdale Canal to the Irwell by a canal that had four locks and a long tunnel. Expected traffic figures were never achieved and the canal was purchased by the Mersey & Irwell Company. The top half became disused in 1875 to make way for the new Great Northern Goods station and Manchester Central station. The bottom-half link to the Irwell was retained, as was the underground tunnel under the goods station, but it ceased to have any use during the 1920s. (*Ray Shill 786582*)

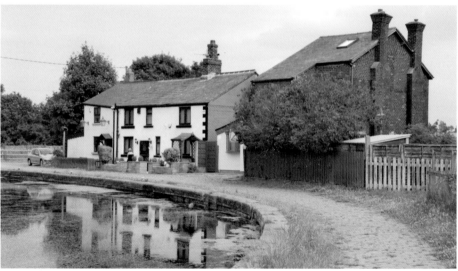

Nob End, Bolton Branch, Manchester Bolton & Bury Canal, 2013
This is a view that many working canals would be proud of: cottages beside a canal full of water and a cobbled towpath. All that is missing is a barge and horse! This scene is deceptive, however, as long sections of the canal nearby have been drained, including the locks behind these cottages. (*Ray Shill 762946*)

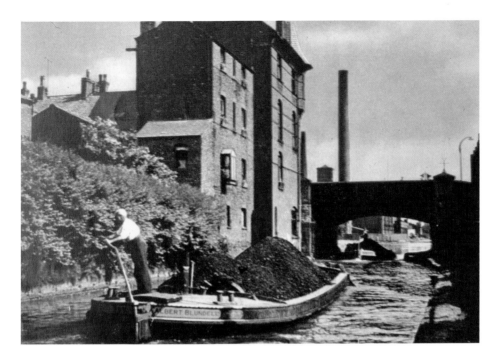

Bridgewater Mill, Patricroft, Leigh Branch, Bridgewater Canal

The route through Patricroft was once busy with barges carrying coal from the mines. The barge *Albert Blundell* is seen passing the building now known as Bridgewater Mill. Patricroft was once the home of the engineering firm Nasmyth, Wilson & Co. Nasmyth produced a variety of steam-driven stationary plant and locomotives at the Bridgewater Foundry, which was established alongside the Bridgewater Canal north of the Liverpool & Manchester Railway Bridge over the canal. (*Above: RCHS Slide Collection 54580. Below: Heartland Press Collection 785302*)

Bridgewater Mill & Patricroft Basin Leigh Branch, Bridgewater Canal, 1958
(*RCHS Hugh Compton Collection, P. Norton 64319*)

Damside Aqueduct, Near Darcy Lever, Manchester Bolton & Bury Canal, 1958
The last aqueduct on the canal before Bolton was called Damside on the River Tonge and was demolished in June 1965. (*RCHS Hugh Compton Collection, A. P. Voce 65131*)

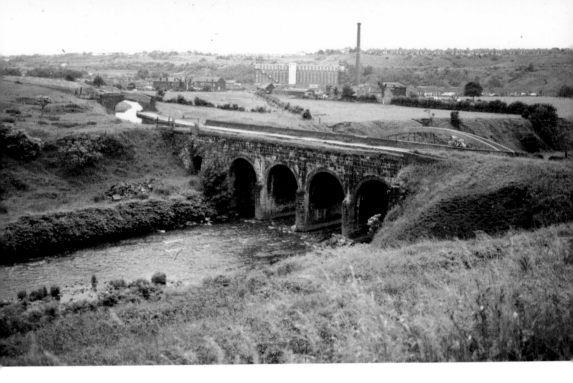

Prestolee Aqueduct, Manchester Bolton & Bury Canal, 1978
Prestolee Aqueduct carried the canal over the River Irwell, which then ascended by six locks (arranged as two pairs of three-lock staircases) to the summit level at Nob End. Vegetation has grown up around the riverbank since this image was taken, but the path across the aqueduct is still well-used by those who follow the paths from Little Lever or Moses Gate to Prestolee. (*RCHS Slide Collection 58735*)

Staircase Locks at Manchester Leading to River Irwell, Manchester Bolton & Bury Canal, 1966
These locks, which provided the link between the canal and the river, were taken down and filled in during 1968. (*Heartland Press Collection 762001*)

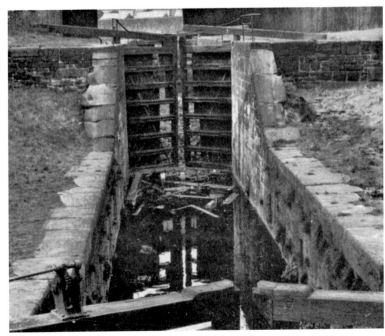

Burrs Aqueduct, Manchester Bolton & Bury Canal, 2013

This aqueduct carries the feeder from the River Irwell over that river at Burrs to Elton Reservoir along a course that is now mostly covered over. There are some iron bridge parapets that survive on this section, however. Elton Reservoir provided the water for the canal. (*Above: Ray Shill 763651. Below: Ted Cheers 763649*)

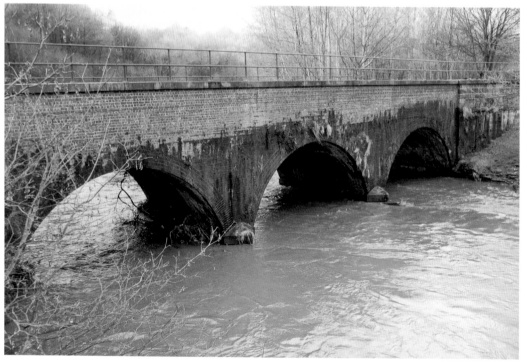

Elton Reservoir Near Bury, Manchester Bolton & Bury Canal, 2013
The feeder from the Irwell enters the reservoir on the east side. This reservoir was completed in 1842. Initially, the canal took water directly from an inlet out of the River Irwell that fed directly into the end of the canal at Bury. The reservoir option became necessary after mill owners objected to the loss of water supply to their mills. (*Ted Cheers 763705*)

Store Street Aqueduct, Ashton Canal, 2013
The Ashton Canal crossed Store Street, in Manchester, by a skew aqueduct. This is believed to be the first aqueduct to be made on the skew in Britain. (*Ray Shill 715028*)

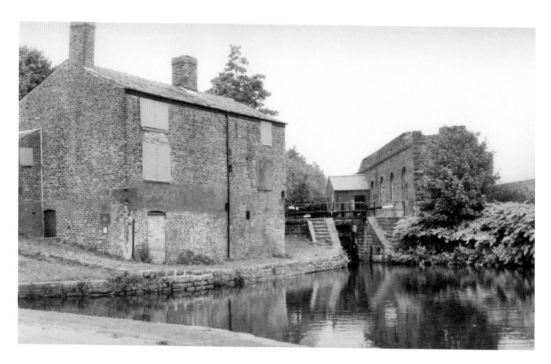

Second Lock & Warehouse, Ashton Canal, 2003
The pound between the first and second lock was also the junction with the Islington Branch, which served a group of different industries but is now only partly in water. (*Ray Shill 715125*)

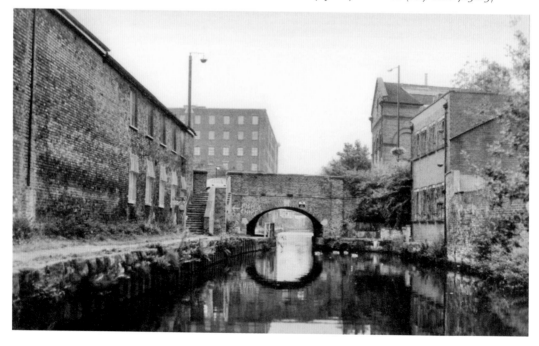

Bridge Factories & Mills, Ashton Canal, 2003
The Ashton Canal passed through an extensive industrial area that lined the canal from Piccadilly through to Fairfield. (*Ray Shill 715161*)

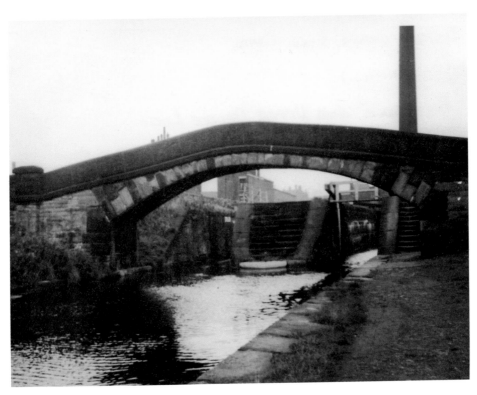

Fairfield Double Lock, Lock 18, Ashton Canal, 1958 and 2008
Fairfield was located at the junction between the main canal and the Hollinwood Branch.
The canal was level from here to the junction with the Peak Forest and Huddersfield Canal.
(*Above: RCHS Hugh Compton Collection 65052. Below: Ray Shill 715745*)

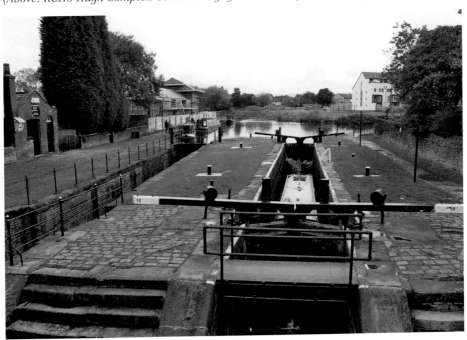

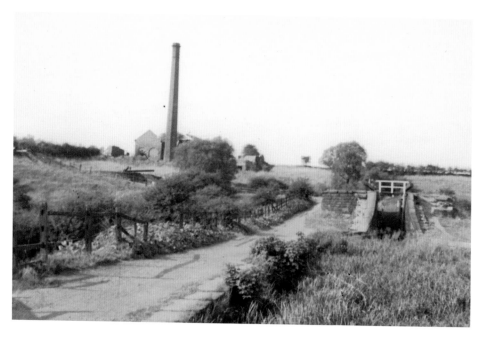

Pumping Engine, Waterhouses & Lock 19, Hollinwood Branch, Ashton Canal, 1959
The branch from Fairfield was level until it reached the outskirts of Waterhouses. From there it climbed through three more locks, 20 and 21 being a staircase pair. In this view, the photographer is standing by the aqueduct over the River Medlock and looking towards Lock 19 and the pumping engine near Waterhouses. (*RCHS Hugh Compton Collection 64065*)

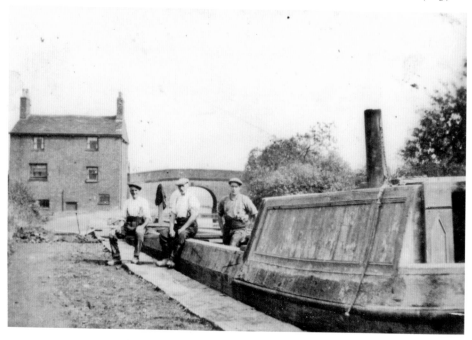

NB *Eagle* at Cutter Hill Bridge, Hollinwood Branch, Ashton Canal, 1935
(*RCHS Hugh Compton Collection, J. A. Hall, 64067*)

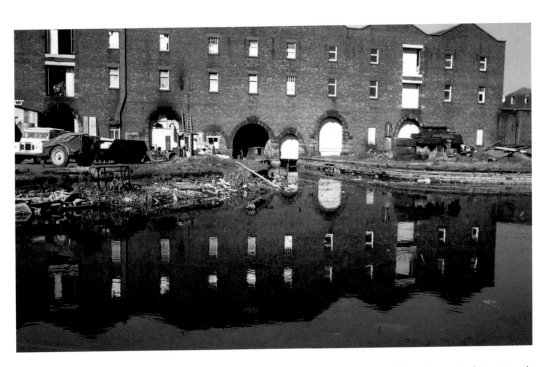

Ashton New Warehouse, 1972, and Iron Waterwheel, Ashton New Warehouse, Ashton Canal
The warehouse faced the junction with the Peak Forest Canal at Portland Basin. This warehouse was later badly affected by a fire, although the wheel has survived. (*Above: RCHS M. Oxley Collection 86187. Below: RCHS Hugh Compton Collection, J. A. Hall, 64057*)

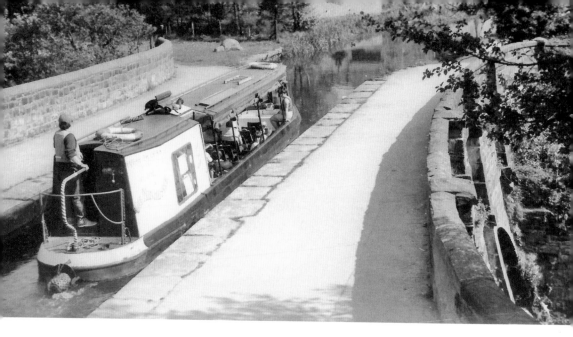

Tame Aqueduct, Dukinfield, Ashton Canal
The Ashton Canal was linked to the Peak Forest by a short branch that crossed the River Tame by a three-arch aqueduct. (*Above: RCHS M. Oxley Collection 86189. Below: Ray Shill 716910*)

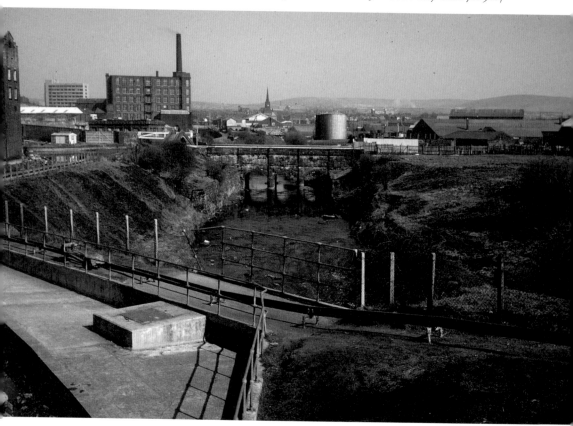

Canal Cottages, Stockport Basin, Stockport Branch, Ashton Canal
(*RCHS Hugh Compton Collection, 64068*)

Lancaster Canal Notice

The *Lancaster Gazette*, 1 May 1813, published the notice requesting contractors to build the two additional sections that enabled the Leeds & Liverpool Canal to link with their waterway.

CANAL MASONRY and CUTTING
TO BE LET,

At the house of THOMAS SCOTT, the Castle Inn,
In Preston, on TUESDAY the 11th May, 1813,
At six o'clock in the evening;

THE MASONRY of SEVEN LOCKS,
And the CUTTING of the CANAL from
Copthurst- lane, the township of Whittle, to the
Lancaster Canal, near Johnson's Hillock, in the
said township- Also the CUTTING of about 500
YARDS in length, of the LANCASTER CANAL,
extending from its present Termination, at Bark
Hill, to the Point of Junction with the Leeds and
Liverpool Canal

§ Specifications of the work may be seen by
Applying at the Canal Office, in Preston and in Lancaster
CANAL OFFICE, LANCASTER,
April 19, 1813

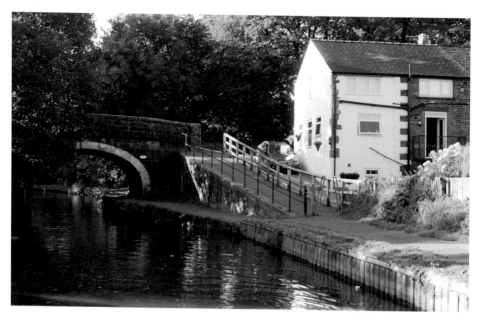

Bridge 71, Heath Charnock, Lancaster Canal/Leeds & Liverpool Canal
A section of the South Lancaster Canal that extended from Wigan Top Lock (Kirklees) to Johnson's Hillock is now part of the Leeds & Liverpool Canal. All engineering features such as bridges and aqueducts can perhaps be credited to the Lancaster Canal engineer for this section, William Cartwright, who died in January 1804. (*Ray Shill 768365*)

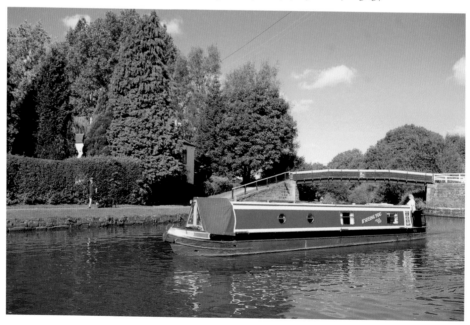

Johnson's Hillock Junction, Lancaster Canal/Leeds & Liverpool Canal
The Lancaster Canal main line of 1803 passed under the towpath bridge (*centre right*) while a link canal to meet the Leeds & Liverpool at Copthurst Lane, built later, now forms the main line of the Leeds & Liverpool Canal. (*Ray Shill 768551*)

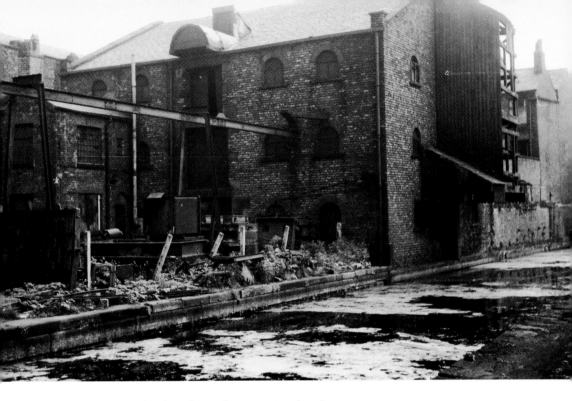

Warehouses and Wharf, Hyde, Peak Forest Canal, 1965
Hyde Warehouse, a fine two-storey building built in 1828, is seen before the developers converted the premises for residential use. (*RCHS Hugh Compton Collection, Brian Lamb, 78331/78332*)

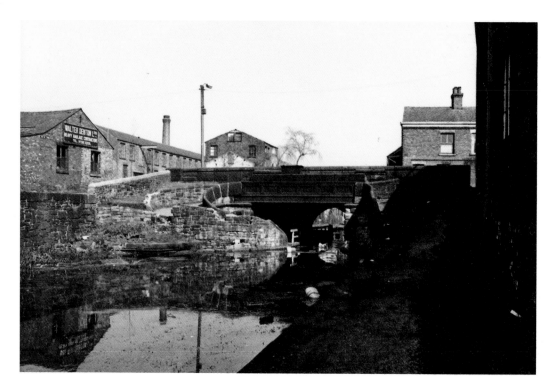

Hyde Turnover Bridge & Woodend Lane Turnover Bridge (Captain Clarke's), Peak Forest Canal
The towpath changes sides twice in a short distance. At Bridge 6 (*above*) there is both a road bridge and an iron turnover bridge and pedestrians can also exit from the towpath to Hyde town centre. At Bridge 7, Captain Clarke's turnover bridge (*below*), the towpath returns to the west bank. (*Above: RCHS Hugh Compton Collection, Brian Lamb, 78334. Below: Ray Shill 717275*)

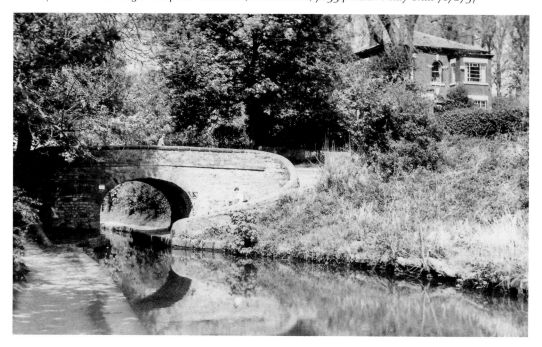

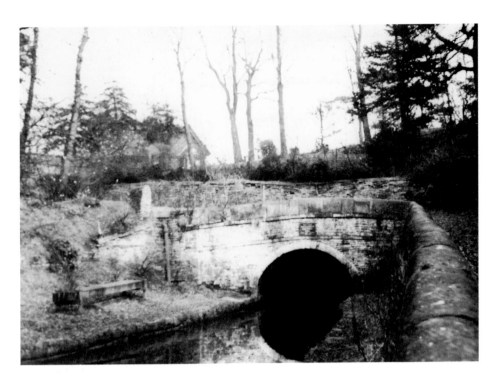

Hyde Bank Tunnel and Hatherlow Aqueduct

The Peak Forest Canal has two tunnels at Woodley and Hyde Bank. The longest of the two is Hyde Bank, where the towpath is carried over the top of the tunnel. At Woodley, the towpath follows the canal through it. There are also several aqueducts, as well as a crossroads – Hatherlow Aqueduct crosses over Green Lane. (*Above: RCHS Hugh Compton Collection 78321. Below: 78317*)

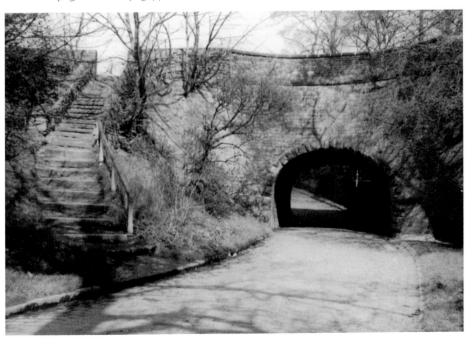

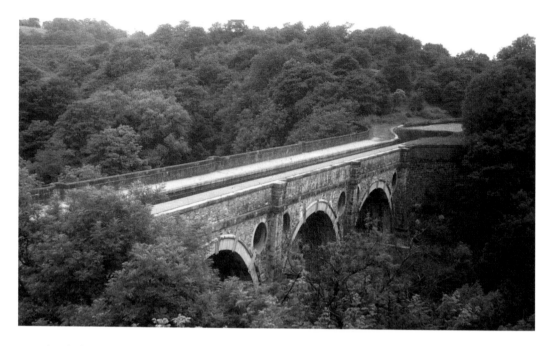

Marple Viaduct, Peak Forest Canal
The Peak Forest Canal crossed the River Goyt, 100 feet below, by a three-arch aqueduct, which was made to the designs of engineers Benjamin Outram and Thomas Brown. Construction began in 1794 and the aqueduct was finished in 1800 for boats to access the temporary tramway link to Marple, while work went on to finish the locks. The structure comprises different stones: the lower part is red sandstone hewn from Hyde Bank Quarry, while the upper part is white stone. (*RCHS Slide Collection 59360*)

Marple Viaduct, Peak Forest Canal, 1963
During its period of closure, water was piped across Marple Viaduct. (*RCHS Hugh Compton Collection 78341*)

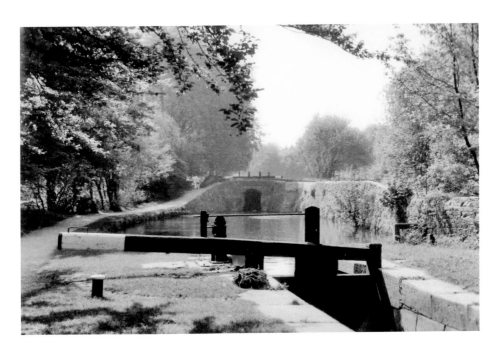

Marple Locks, Peak Forest Canal
The Peak Forest Canal had two levels: the summit level to Bugsworth and Whaley Bridge, and the level joining the Ashton at Dukinfield. A single flight of sixteen locks (a rise of 209 feet) at Marple opened in 1804, linked these two levels and also met the Macclesfield above the top lock. (*Ray Shill 717775*)

Posset Bridge, Horse Tunnel and Lock Tunnel, Peak Forest Canal
The lock at Posset Bridge has the unusual arrangement where the boatmen had a separate passage to their craft to the horses. (*Ray Shill 717895*)

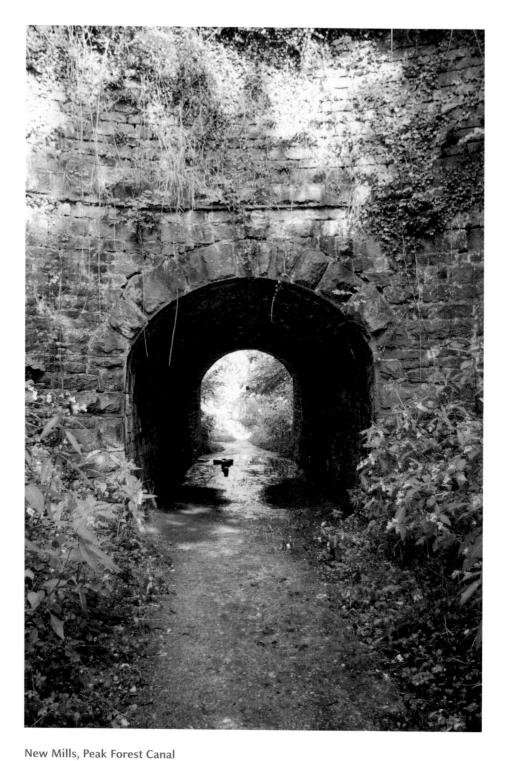

New Mills, Peak Forest Canal
Bridgemont Aqueduct (Horse Path Tunnel), near Bugsworth, Upper Peak Forest Canal. Towpath access for horses from the canal to Bugsworth to the Whaley Bridge Branch was made possible by the Bridgemont Aqueduct that spanned the link. (*Ray Shill 718561*)

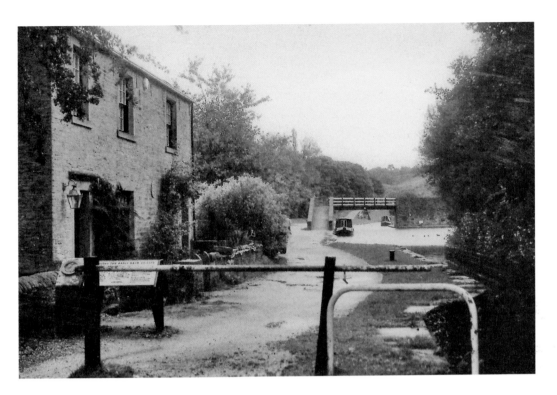

Wharfingers House, Bugsworth, Peak Forest Canal
(*Ray Shill 718591*)

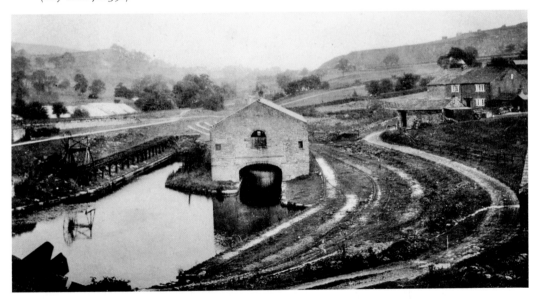

Bugsworth Basin, Peak Forest Canal
The Peak Forest Tramway brought limestone down to the group of basins at Bugsworth (later Buxworth). The tramway comprised plate rails laid on stone locks to a gauge of 4 feet 2 inches. The tracks divided into different lines around the basin and also served the limekilns (far right).
(*RCHS Baxter Collection 29012*)

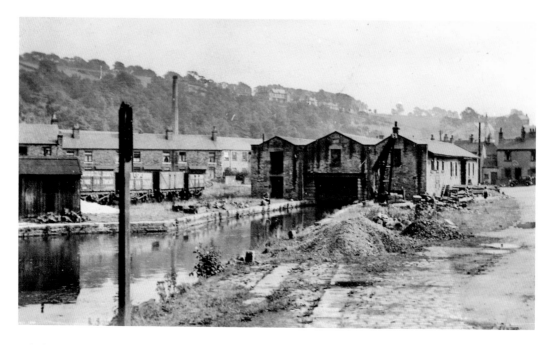

Whaley Bridge Basin, Peak Forest Canal
The Cromford & High Peak Railway terminated at Whaley Bridge, and it was here that interchange facilities were provided. (*RCHS Baxter Collection 20420*)

Junction Leeds & Liverpool Canal and the Bridgewater Canal (Leigh Branch)
The Bridgewater Canal from Worsley was extended to Leigh, providing canal accommodation to this mill and mining town. The Leeds & Liverpool Canal also built a branch from Wigan, which formed an end-on connection with the Bridgewater Canal there. (*RCHS Hugh Compton Collection 64330*)

Junction Leeds & Liverpool Canal and the Bridgewater Canal (Leigh Branch), 1998 (*Ray Shill 785721*)

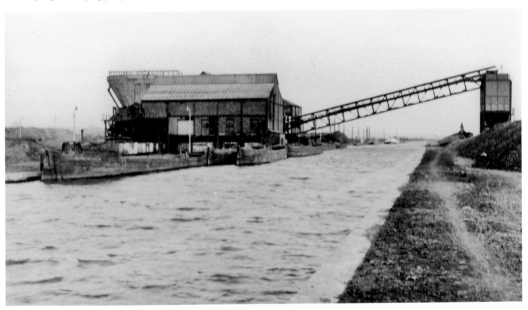

Astley Green Colliery, Leigh Branch, Bridgewater Canal

The canals to Leigh passed through an extensive mining area. Astley Green was a modern pit owned by the Manchester collieries. It was at the western end of their long private railway network and was located in a somewhat windswept and desolate place, where the ground was often boggy and peat cutting was carried on. Astley Green Colliery loaded coal into boats alongside a long wharf served by the pit railway. (*RCHS Hugh Compton Collection 64324*)

Chapter Three
Routes Across the Pennines

Leeds & Liverpool and Rochdale

There were three routes across the Pennines: two (Leeds & Liverpool and Rochdale) were barge waterways and the third (Huddersfield) could pass only narrowboats but had the longest canal tunnel (Standedge) in the country.

The Leeds & Liverpool may be considered the oldest of this group. Construction started at both ends during the eighteenth century and was extended in stages, with various route changes towards the middle. Such was the duration of the construction period that there were contrasts along the length of the completed canal. The canal infrastructure varied in this respect with the Liverpool side steadily climbing up to the summit at Foulridge and descending again through locks set more closely together. They were arranged as staircases until the craft finally locked down into the River Aire at Leeds. At 127 miles long, it is one of the longest linear canal routes in Britain. The canal was opened in stages between 1773 and 1816, with the branch to Leigh completed in 1820. From 1863 the South Lancaster Canal from Kirklees to Walton Summit and the locks at Johnson's Hillock were leased to the Leeds & Liverpool Canal Company. It was an agreement that was ratified by the Lancaster Canal Transfer Act (1864).

With the Rochdale, the route began with a junction with the Bridgewater and involved first tunnelling and then a steady series of locks to a summit near Littleborough. Here, the canal descended again through another series of locks to Sowerby Bridge, where it joined the Calder & Hebble Navigation.

Both routes were barge waterways, which linked Lancashire with Yorkshire and also enabled traffic between these different places. While the Leeds & Liverpool took the northern route, passing through the mining town of Wigan and the mill towns of Blackburn, Burnley and Nelson, the Rochdale started in Manchester and steadily climbed through a series of locks to Rochdale and Littleborough. The Rochdale also had two short branches, one to Haywood and the other at Rochdale.

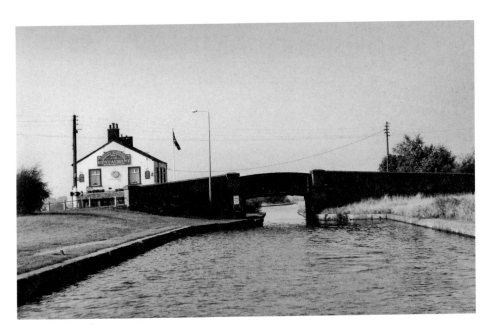

Dover Locks (Site), Leeds & Liverpool Canal, Leigh Branch
There were two locks at Dover. The chambers remain but became a level navigation when the level was reduced through subsidence. (*Ray Shill 770361*)

Lock 67, Top Lock, Wigan, Leeds & Liverpool Canal, 1998
The Wigan locks comprise twenty-one locks (87–67), which rise 215 feet. All these locks, like the remainder to Leeds, had a length of 62 feet for boats up to a beam width of 14 feet 4 inches. Below Wigan to Liverpool, the remaining locks were longer having a length of 72 feet. The Leeds & Liverpool Canal Company arranged for the construction of these locks, which were ready for traffic during 1816. (*Ray Shill 768205*)

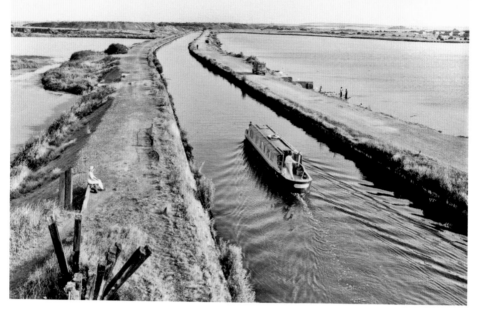

Leeds & Liverpool Canal, Leigh Branch
The serious mining subsidence that affected the Leigh Branch left areas of land covered by water. (*RCHS Canal Print Collection 40355*)

Junction House, Walton Summit Branch, Leeds & Liverpool Canal
The Lancaster Canal divided at the tail of the bottom lock for the Johnson's Hillock flight. This house occupied the strategic position facing the junction of the Walton Summit Branch with the lock flight that made the connection with the Leeds & Liverpool Canal to Blackburn. (*Ray Shill 768550*)

Johnson's Hillock Locks, Leeds & Liverpool Canal, 1967 & 1998
The seven locks that comprise the lock flight at Johnson's Hillock were built for the Lancaster Canal Company when Thomas Fletcher occupied the post of engineer. (*Above: RCHS Kevin Gardiner Collection 67195. Below: Ray Shill 768576*)

Johnson's Hillock Top Lock, Leeds & Liverpool Canal
Lock 58 in the Leeds & Liverpool Canal lock numbering sequence was also the top lock of the flight built for the Lancaster Canal Company. The Leeds & Liverpool Canal Company leased these locks and the canal through to Kirklees from the Lancaster Canal Company during 1863. (*Ray Shill 768587*)

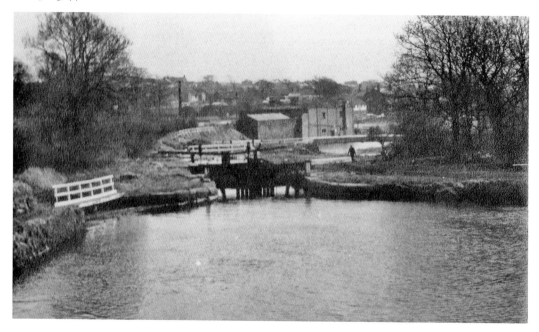

Bottom Lock and Canal Side Buildings, Johnson's Hillock Locks, Leeds & Liverpool Canal
There was a group of buildings on the towpath side of the canal below the last lock. These have now been removed. (*RCHS K. Gardiner Collection 67194*)

Walton Summit Branch, Lancaster Canal
The 3-mile length of waterway from waterway Johnson's Hillock to Walton Summit formed part of the South Lancaster Canal that was completed during 1803. (*RCHS K. Gardiner Collection 67184*)

Whittle Hills Tunnel, Lancaster Canal
The short Whittle Hill tunnel (259 yards) was a rare infrastructure feature on what was otherwise a level canal. William Cartwright, engineer, believed it would only require a year to make, yet the contractors building this tunnel found it difficult to cut through and two years were needed to complete it. (*RCHS K. Gardiner Collectin 67182*)

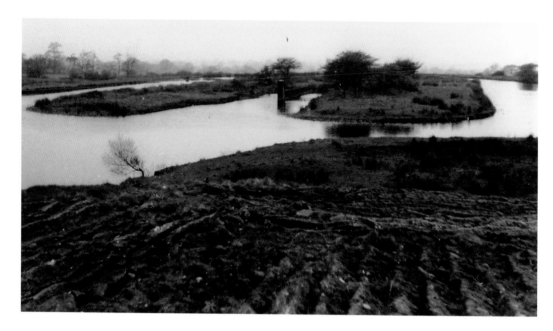

Walton Summit and Tramroad Terminus Basin, Lancaster Canal
The southern section of the Lancaster Canal terminated at Walton Summit where basins were provided for interchange with wagons that operated along the canal plateway to Preston. (*RCHS Hugh Compton Collection 64933*)

Tramroad Terminus Basin and Warehouse, Lancaster Canal, 1936
A covered warehouse was provided for interchange traffic. This structure was pulled down, although part of the wall remained. (*RCHS Hugh Compton Collection, Bertram Baxter 64930*)

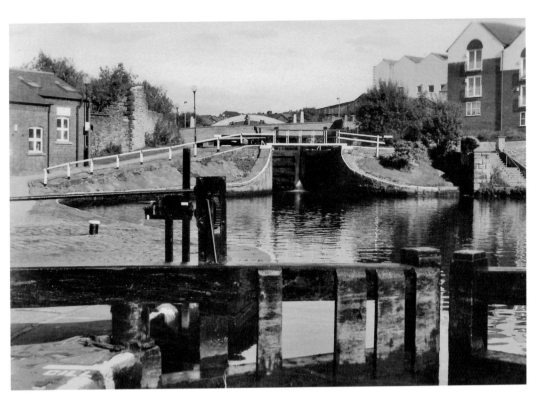

Locks at Nova Scotia, Blackburn, Leeds & Liverpool Canal
The canal rises through five locks as it passes through the Nova Scotia District of Blackburn. The pound between locks 2 and 3 was made almost circular (*above*). The canal had many cotton mills along its banks and there was an almost continuous line of mills leading to the top lock (*below*), which included the Commercial, Nova Scotia and Rockcliffe Mills. (*Above: Ray Shill 768740. Below: 768750*)

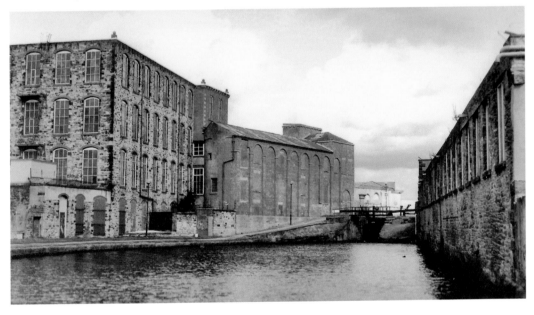

Eana Wharf Warehouses, Blackburn, Leeds & Liverpool Canal
Building the canal gradually proceeded eastwards through Burnley, Rishton and Blackburn, Blackburn was reached during 1810. With the building of the canal various industries were established along the waterway and to cater for a variety of merchandise goods, a warehouse was established at Eana Wharf. (*Ray Shill 768770*)

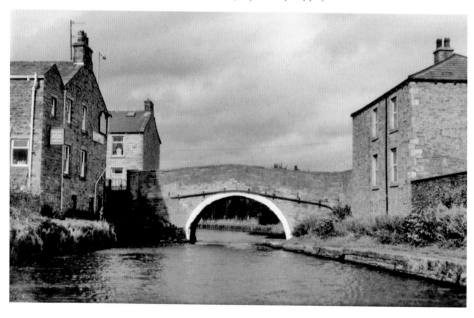

Rishton, Blackburn, Leeds & Liverpool Canal
Contractors building the canal through and by Rishton involved the building of embankments and cutting through higher ground nearer Blackburn. The embankments required time for consolidation before they were stable enough to let water into the channel. (*Ray Shill 768805*)

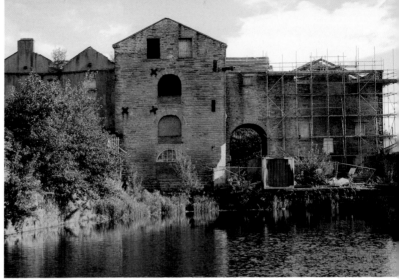

Church Warehouse, Near Accrington, Leeds & Liverpool Canal, 1998 & 2009
Warehouses like Church were placed near a turnpike that conveyed goods to nearby towns. The nearest town to Church was Accrington, which was a mile away. There were also cotton mills, printing and dyeing works, and a short branch canal to Peel Bank. (*Ray Shill 768843 and 768846*)

Leeds and Liverpool Canal
DIGGING and MASONRY
TO BE LET

At the Gender's Arms, In Whalley, On Thursday the 15th
Day August,
1807, in such lots, and on such Conditions as will be then
produced

THE DIGGING of Part of the said Canal, from a certain
place called Fox-Hill- Bank, to the Turnpike Road
at Rushton, near Blackburn, in the County of Lancaster;
and the BANKING of the Aspin Valley, Aspin Clough,
and Munsfield Clough.

Also, THE MASONRY of Several Occupation Bridges,
of and Aqueduct over Aspin Valley, and of Five other
Culverts, all in the Line of the above Digging.

Plans and Specifications, may, in the mean mTime, be
Seen, and other Particulars obtained, by applying to
Mr James Fletcher, at Gannow, near Burnley

Reproduced from the *Leeds Mercury*, 15 August 1807.

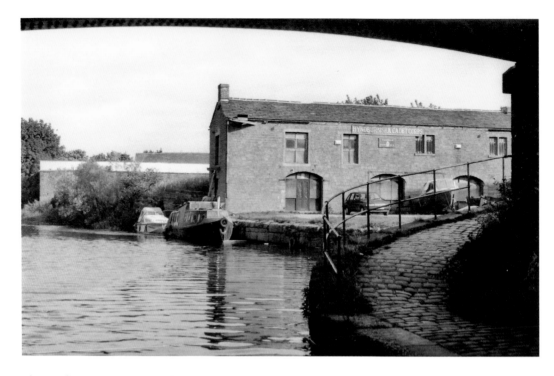

Clayton-le-Moors, Near Accrington, Leeds & Liverpool Canal
The warehouse at Clayton-le-Moors, known as Enfield Wharf, was near a major road to Accrington. (*Ray Shill 768886*)

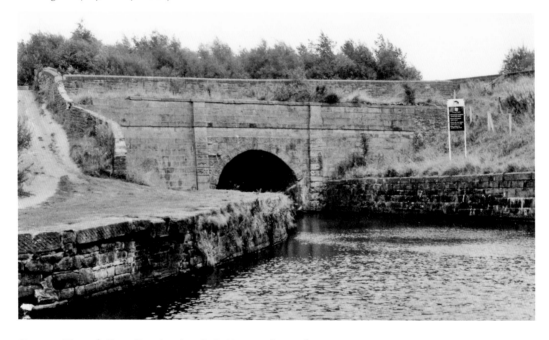

Gannow Tunnel, Near Burnley, Leeds & Liverpool Canal
The completion of Gannow Tunnel (559 yards) in 1801 enabled the canal to be opened from Burnley to Enfield. (*Ray Shill 768926*)

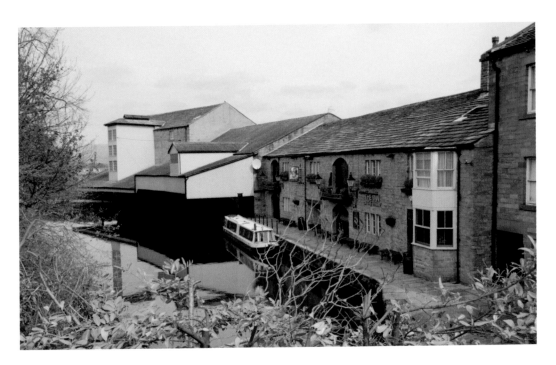

Burnley Warehouse, Leeds & Liverpool Canal
(*Ray Shill 768988*)

Burnley Embankment, Leeds & Liverpool Canal
Robert Whitworth, engineer, produced several schemes to cross the valley at Burnley. The one chosen was set out during 1795 for a straight embankment that was 40 feet high and almost a mile long and included within its length an aqueduct over Yorkshire Street and a culvert channel for the River Calder. (*RCHS Slide Collection 58410*)

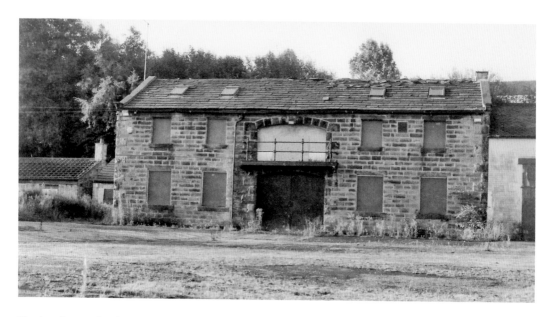

Finsley Gate Wharf and Yard, Burnley
The Leeds & Liverpool Company wharf and dockyard was once a place where boats were built and maintained. (*Ray Shill 769000*)

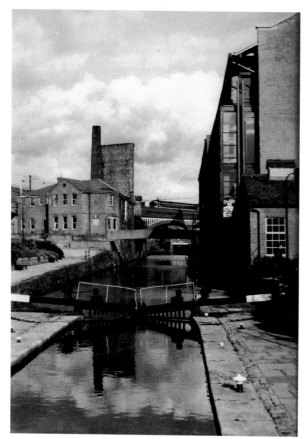

Lock 92 and Canal Looking Towards Deansgate Tunnel, Rochdale Canal, Manchester
The Rochdale Canal climbed up from Castlefield to Piccadilly through nine locks, which modern boaters called the 'Rochdale Nine'. This part of the waterway came to be lined with tall buildings on both sides, but when first built this part was covered over as Deansgate Tunnel. (*Ray Shill 833531*)

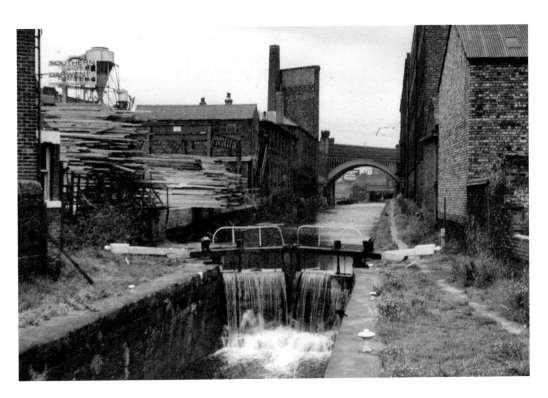

Lock 92 and Timber Yard, Rochdale Canal, Manchester
From 1952 traffic was restricted along the Rochdale Canal and only the section from Ashton Junction to Castlefield (the Rochdale Nine) remained open. (*RCHS Slide Collection 59452*)

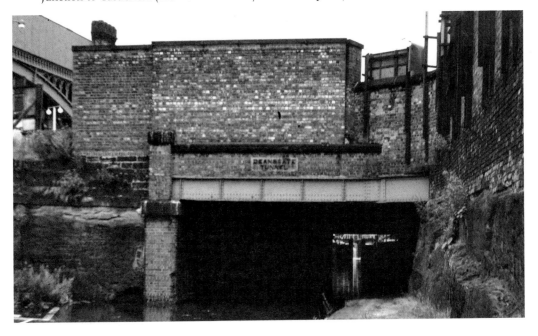

Deansgate Tunnel, Rochdale Canal, Manchester
(*RCHS Slide Collection 59543*)

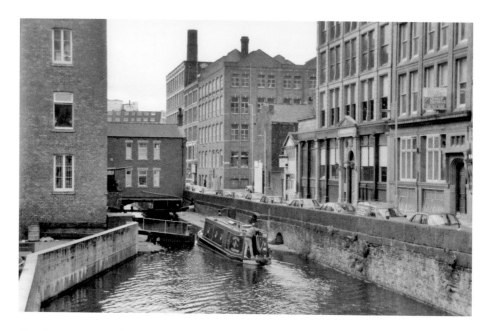

Chorlton Street Lock, No. 86, Rochdale Canal, Manchester
The Rochdale Canal passed between tall buildings south of Piccadilly and included a section without a towpath. Boat crews are required to travel with their craft to reach this isolated spot. (*Ray Shill 833721*)

Rochdale Canal Company Offices, Dean Street, Manchester
The offices fronted Dean Street and were adjacent to the entrance to the wharf and warehouse. The tall building, far right, was the railway warehouse built on the Ashton Canal wharf. (*Ray Shill 833750*)

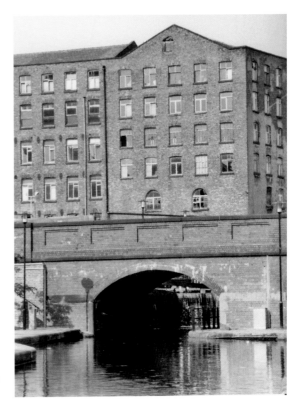

Manchester, Rochdale Canal
Cotton spinning became a staple trade for Manchester and the towns around it. The nineteenth-century Brownsfield Mill, 1825, remains a dominant feature beside the canal and Great Ancoats Street that crosses the canal there. (*Ray Shill 833865*)

Manchester, Rochdale Canal
Another group of surviving cotton mills along the canal are to be found near Lock 82. They include a range of buildings, the earliest being Murray's Mill, which was later joined by the Old Mill, McConnel & Kennedy Mill and Sedgewick Mill. During the twentieth century, the Paragon and Royal Mill were added to this mill complex and all are separated from the canal by Redhill Street. The iron 'Kitty Footbridge' over the canal is another survivor from the canal age. (*Ray Shill 833901*)

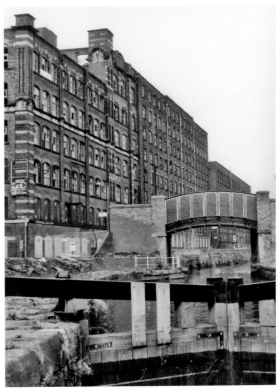

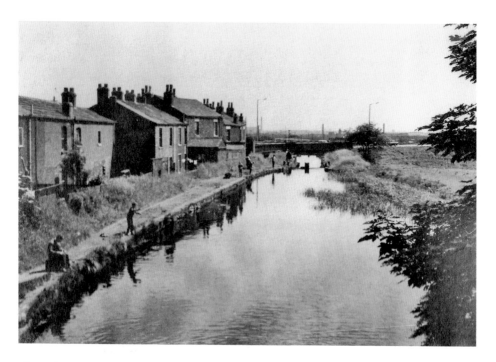

Slattocks Locks, Rochdale Canal, 1967

Traffic along the Rochdale Canal declined during the 1930s and was negligible when in 1952, the still independent Rochdale Canal Company obtained and Act to prevent the public right of navigation along the canal with the exception of the section in Manchester. The towpath like the locks at Slattocks were still used by pedestrians, for fishing and for other related leisure activities. (*RCHS K. Gardiner Collection 67426 & 67429*)

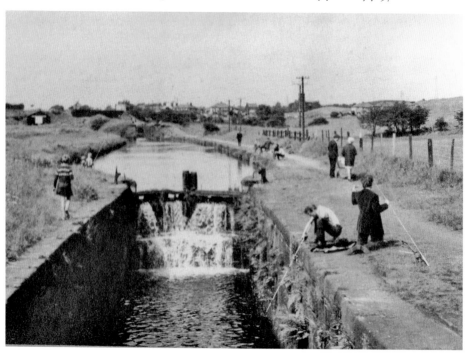

Slattocks Locks, Rochdale Canal,
2003 & 2013
(*Ray Shill, 844505*)

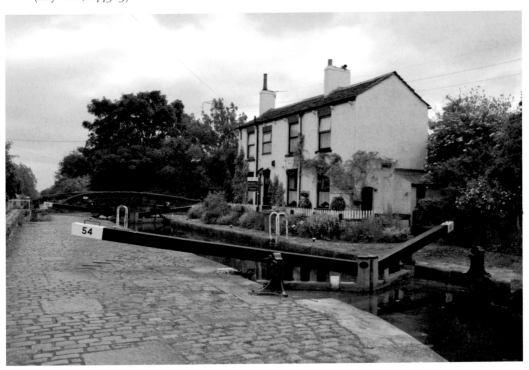

Chapter Four
Manchester Canal Port

Manchester's first navigation was the Mersey & Irwell, which had wharves near a sandstone cliff on the Manchester side of the river. Nearby was an area known as Castlefields, through which the River Medlock flowed. Castlefields in Manchester was chosen as the terminus of the Bridgewater Canal, where a section of the River Medlock was adapted for the canal as well as providing an important water supply. Surplus water then flowed over a circular weir and was returned to the river channel to flow into the Irwell.

It was at Castlefields that a group of canal carriers decided to establish warehouses and wharves for the merchandise trade. There were seven major warehouse structures that handled cargoes brought in by barges, flats and narrowboats. Interchange of traffic was particularly important, as this area was the meeting point of the Rochdale and Bridgewater canals. Trade between Lancashire and Yorkshire was handled here as well as traffic from, and to, the Potteries, East Midlands, West Midlands and London by narrowboat. Traffic from the south was generally confined to a particular type of boat, the 'flyboat', which travelled the canals calling at specific wharves and at all other times was in motion both day and night. The warehouses lined the Bridgewater at Castlefield and were named as follows: Grocers, Kenworthy, Merchants Middle, New, Old and Staffordshire.

The making of the Rochdale Canal opened up additional wharves along its length in the city and in particular basins were constructed at Dickenson Street, Dean Street, City Wharf, Pott Street and Prussia Street. The Ashton Canal also had wharves and warehouses that faced Piccadilly.

Piccadilly came to have a strategic role for narrowboat traffic once the Macclesfield Canal was completed. Some flyboats found the route via the Peak Forest and Ashton a direct course to Manchester. With the development of the railway network, flyboats lost a core element of their trade, but flyboat operators continued to handle specialist cargoes and successfully competed in their share of the carrying market, for a time at least. The making of the Manchester Ship Canal upgraded the status of the city to a port serving seagoing vessels and marked the transition from a canal port to a seaport. Large seagoing vessels passed along the Ship Canal to Trafford Park and Salford where the large dock complex was situated.

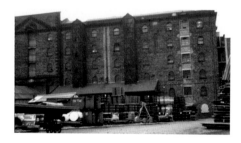

New Warehouse, Castlefield, Manchester, Bridgewater Canal
The New Warehouse fronted Ellesmere Street and was served by a wide basin that joined the Bridgewater west of the other wharves and warehouses.

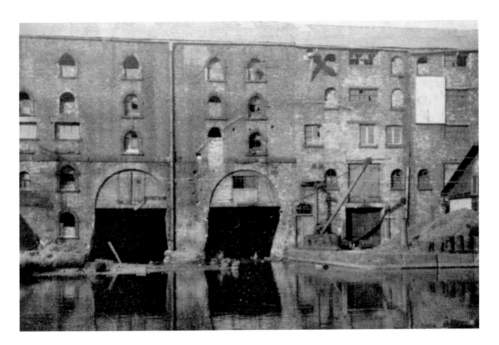

Grocers' Warehouse, Castlefield, Bridgewater Canal, Before & After Demolition
The Grocers' Warehouse is named after the Manchester Grocers' Company that came to
own it. These buildings were an enlargement of an earlier structure that was built for the
canal carrying companies Hugh Henshall and Worthingtons, and once enlarged continued
to be used by a succession of canal carriers until that trade declined (1850s). Each arch
spanned a loading dock for the warehouse, while the waterway on the left side joined up
with a subterranean canal that extended into the rock of the hillside. After demolition, this
warehouse site was used for stacking coal, but was then restored to expose the tunnel and
loading wharves. (*Above: Heartland Press Collection 784801. Below: Ray Shill 784805*)

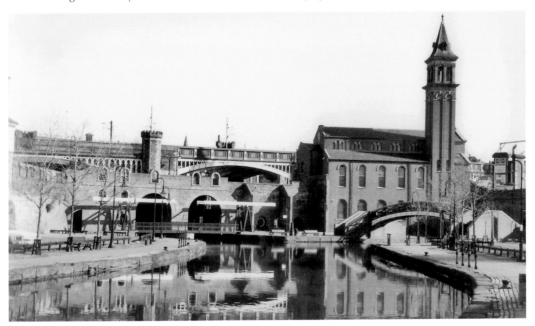

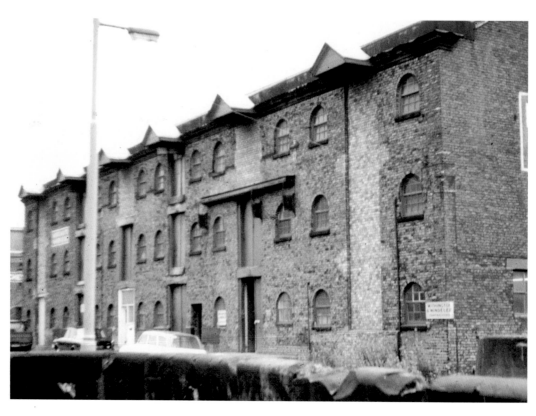

Warehouse, Manchester, Bridgewater Canal

The upper image shows Merchants Warehouse as seen from the street. The lower image shows the warehouse as seen from the canal. (*Above: RCHS Slide Collection 54565. Below: 54566*)

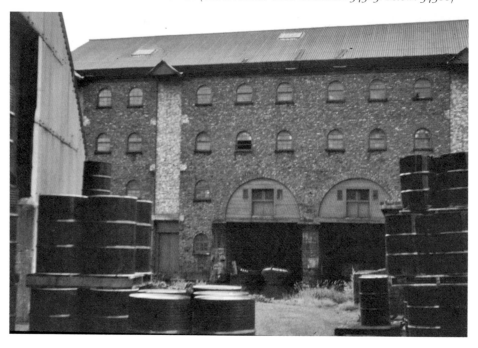

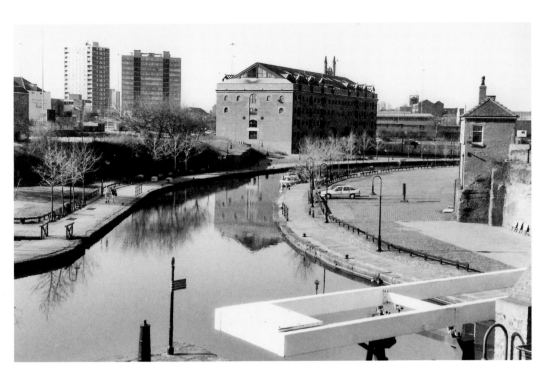

Middle Warehouse, Castlefield, Manchester, Bridgewater Canal
The massive Middle Warehouse has survived to be redeveloped as offices. (*Ray Shill 784798*)

Dean Street Warehouse, Manchester, Rochdale Canal
The Rochdale Canal Warehouse in Dean Street was retained for industrial use long after it ceased to have a function for canal transport. (*Ray Shill 833755*)

Chapter Five
Railways & Railway Ownership

The first railways in this area were of edge rail or plate rail, which was often laid on stone blocks. They included the canal tramways that were: Lancaster (Walton Summit Basin–Preston); Peak Forest (Marple Locks; removed 1804 when the locks were completed); and Peak Forest (Bugsworth–Chapel Milton–Peak Forest Limeworks & New Line Quarries).

Railway companies acquired the following waterways: Ashton (Manchester Sheffield & Lincolnshire Railway, 1848); Lancaster (London & North Western Railway, 1885); and Peak Forest (Sheffield, Ashton-under-Lyne & Manchester Railway, 1846).

The Manchester Bolton & Bury Canal Company also became a railway company from 1831. They built a railway close to the route of the canal and amalgamated with the Manchester & Leeds Railway Company in 1846.

Otherwise, the railways crossed the existing waterways, sometimes by brick, stone or iron bridges but also by viaducts. Such was the nature of the terrain that structures were frequently large and imposing.

One of the later railways to be built through this district was the Cheshire Lines Committee, whose constituent member railways were the Great Central, Great Northern and Midland Railway companies. Their route often involved extensive engineering to cross and pass previously established waterways and railways.

In addition to the public railways, there were the private railways that brought commodities to the canal side. Several colliery railways had coal drops or wharves alongside the waterway. Gasworks too had wharves for the loading of by-products such as tar and coke.

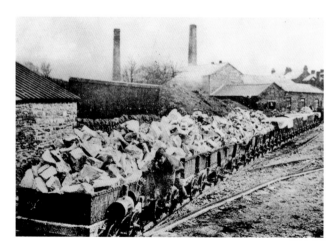

Peak Forest Tramway
The line was a plateway that linked various limestone quarries near Chapel-en-le-Frith with the Peak Forest Canal at Bugsworth. (*RCHS Bertram Baxter Collection 29061*)

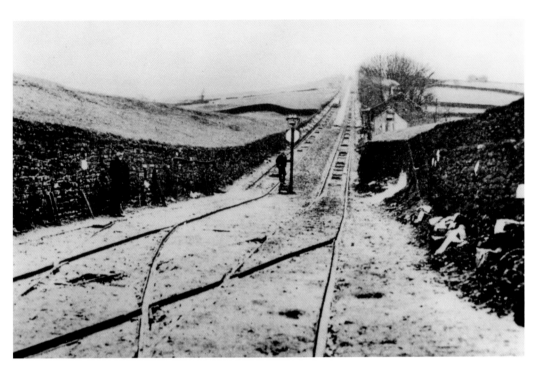

Chapel-en-le-Frith, Peak Forest Tramway and Shatterford Incline, Cromford & High Peak
There is a contrast with the type of rail in these two railway inclines. The upper image shows the Peak Forest plateway incline at Chapel-en-le-Frifth, while the lower image has a view looking down the Shatterford Incline to Whaley Bridge and the edge rails laid there. (*RCHS Bertram Baxter Collection 29060 and 20422*)

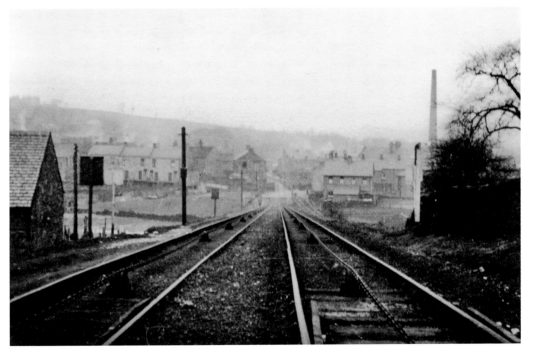

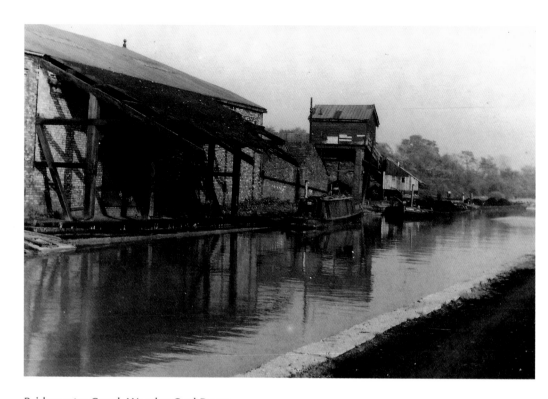

Bridgewater Canal, Worsley Coal Drops

The Duke of Bridgewater's mines also had surface tramways to the canal. The Wardley Tramway linked the Sanderson Pits at Roe Green with the canal at Worsley. From 1865, the tramway system was reconstructed as a standard gauge railway that linked a number of deep coal mines with the national rail network and the canal. (*RCHS Hugh Compton Collection, P. Norton 64309/310*)

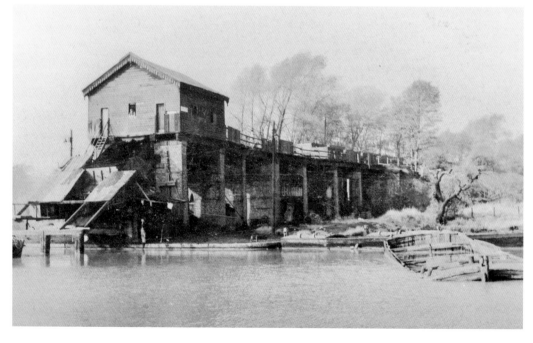

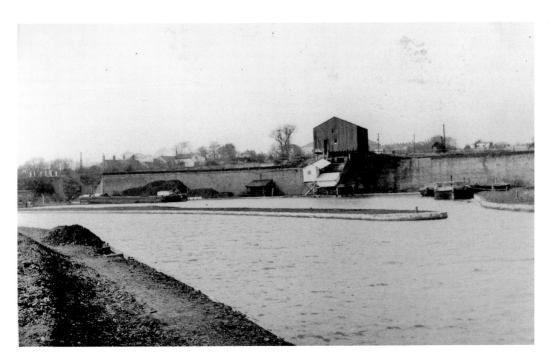

Coal Drops, Boothstown Leigh Branch, Bridgewater Canal
The Ellenbrook Tramway was a separate line to mines near Little Hulton. This line was also relaid as a standard gauge railway as part of the railway construction scheme instituted from 1865, which created a unified private railway that served new sinkings such as Mosley Common. (*RCHS Hugh Compton Collection, P. Norton 64320*)

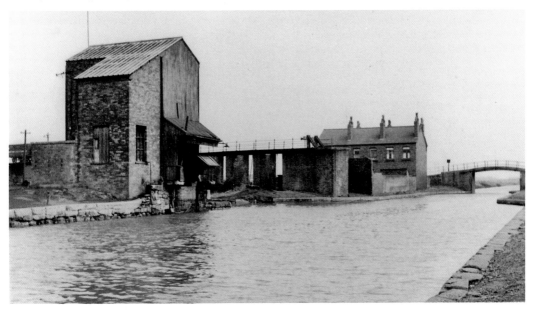

Bedford Colliery Loading Wharves, Marsland Green, Leigh Branch, Bridgewater Canal
The Bedford Colliery company owned pits, including Bedford and Gin, which had branches to the Bridgewater Canal. (*RCHS Hugh Compton Collection 64326*)

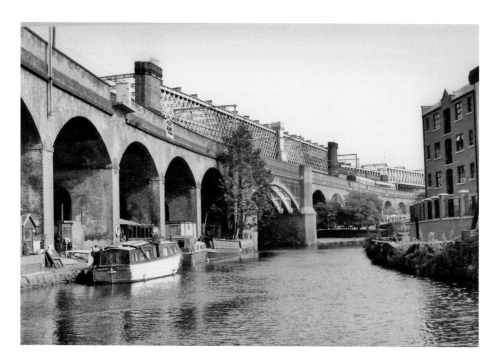

Railway Viaducts, Castlefields, Bridgewater Canal and Pomona Docks

A dominating feature of the Castlefields area of Manchester is the two railway viaducts that pass close to the canal. The lower of the two was built for the Manchester South Junction & Altrincham Railway, which linked the Liverpool & Manchester line with London Road (now Piccadilly) station. The second, taller structure was the Cheshire Lines Committee, which provided rail access to Manchester Central station and the Great Northern railway goods depot. The higher line is used today by Metrolink services (trams) travelling between Manchester City Centre and Altrincham, East Didsbury, Eccles and Media City. (*Above: Ray Shill 784746. Below: Ray Shill 784695*)

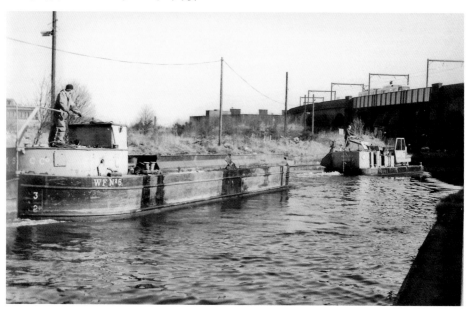

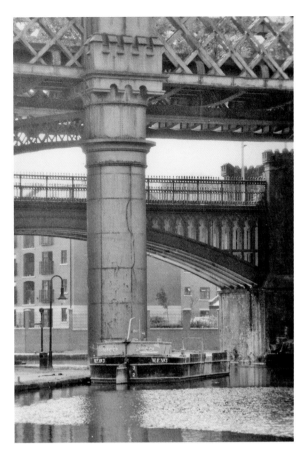

Cheshire Lines Committee, Railway Viaduct, Castlefields, Bridgewater Canal
The massive iron supports for the Cheshire Lines Committee railway rise like a cathedral arch to the tall viaduct that was made to cross not only the canal but also the Manchester South Junction & Altrincham Railway line from Deansgate to Ordsall Lane. Construction of this railway was carried out between 1874 and 1877. Below is the Lancashire & Yorkshire Railway bridge, over the Peak Forest Canal. (*Ray Shill 784747 & 717035*)

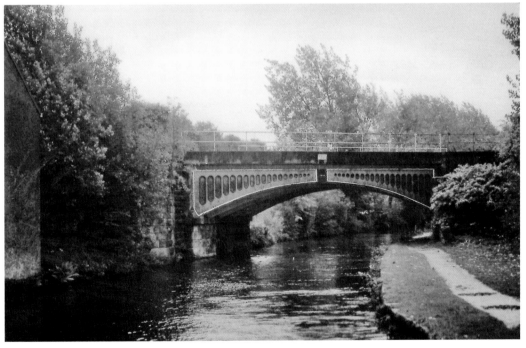

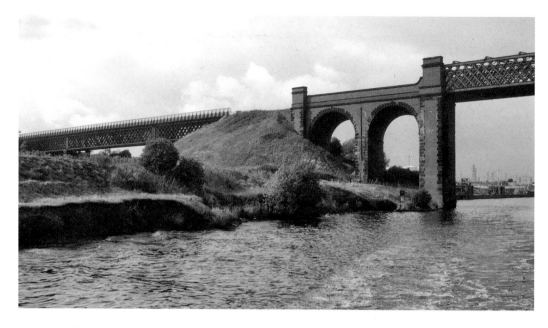

Cadishead Viaduct Over Manchester Ship Canal
The making of the Manchester Ship Canal led to the diversion of railways onto tall viaducts over the canal. At Cadishead the Cheshire Lines Committee route from Glazebrook to Stockport crossed the canal and the surrounding land by viaducts. (*RCHS Slide Collection 58787*)

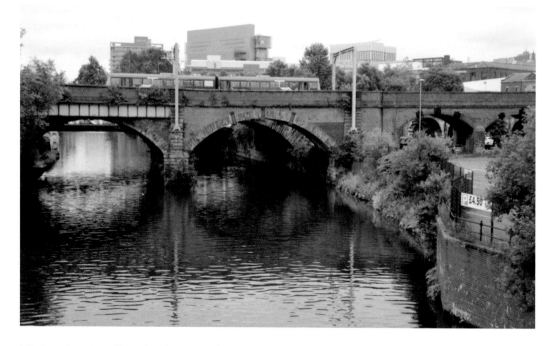

Viaduct Over Irwell Navigation, Manchester
The Manchester South Junction and Altrincham Railway of 1849 crossed the Irwell by a two-arch span bridge that was identical to the span of the earlier Liverpool & Manchester Railway structure. (*Ray Shill 786441*)

Liverpool & Manchester Railway Viaduct Over Irwell Navigation, Manchester
Unlike the massive Earlestown Viaduct that spans the Sankey Brook and Navigation, the crossing of the Irwell in Manchester by the Liverpool & Manchester Railway appears a less significant structure, even if it is just as historically important. The two arches of 65-foot span were built of stone, unlike Earlestown, which was a brick construction but stone faced. (*Ray Shill 786445*)

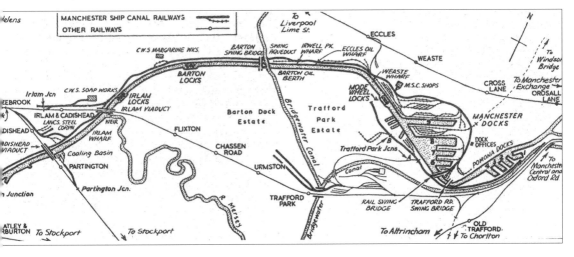

Manchester Ship Canal Railway, Manchester Ship Canal, Manchester
The Manchester Ship Canal operated a railway along the length of the canal, with principal depots at Manchester, Irlam and Ellesmere Port.

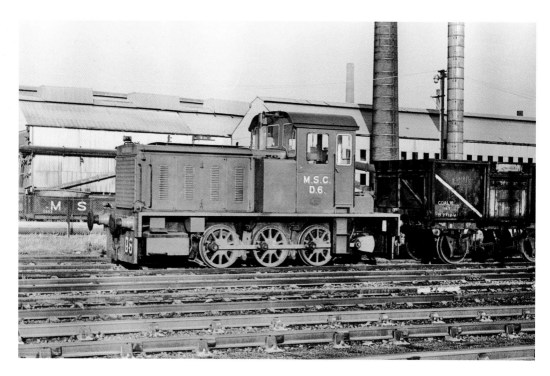

Irlam Sidings and Manchester Ship Canal Railway, Salford Docks, Manchester, 1971
Above, one of the Hudswell Clark diesel locomotives is stabled in the sidings near the Manchester Ship Canal Pallet Store at Irlam. In the lower image, another Hudswell diesel handles traffic on the Manchester Ship Canal sidings adjacent to the Lancashire Steelworks at Salford. (*Ray Shill 781811 and 781815*)

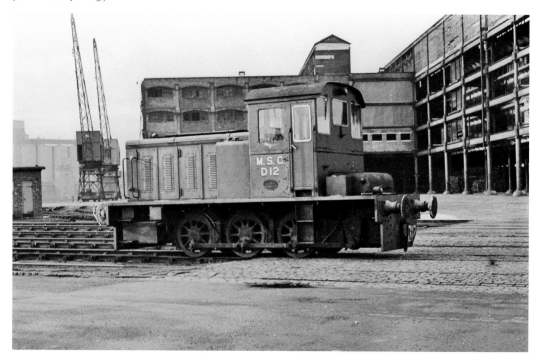

Chapter Six
Canal & River Improvements

Bridgewater, Leeds & Liverpool, Manchester Bolton & Bury and Manchester Ship Canal

A major scheme in the Manchester area was the making of the ship canal that raised the port status of a canal and river port to one that dealt with seagoing vessels. Construction started at Eastham beside the Mersey estuary and proceeded via Ellesmere Port, Runcorn, Latchford, Irlam and Barton. The channel was made deep and wide enough to pass large vessels with two sets of lock chambers at each of the locks: Latchford, Irlam, Barton and Mode Wheel.

Railway lines were raised high over the canal to provide suitable clearance for the vessel. Locks on the Mersey & Irwell Navigation between Bucherfield and Throstle Nest (the uppermost lock) were removed or ceased to have a function. The waters of the River Mersey that flowed into the Irwell west of Irlam were diverted into the canal course, as was the River Irwell from Manchester. The canal terminated in the vast dock complex that comprised the docks at Salford, the wharves at Trafford Park and the docks known as Pomona. The ship canal was continued as the Upper Reach of the River Irwell beyond Pomona and retained the navigation through to Central Manchester, serving the Old and New Quays as well as the links to the Manchester & Salford Junction Canal and the Manchester Bolton & Bury Canal.

The ship canal was finished in December 1893 and opened in January 1894. This company had taken over the Bridgewater Navigation from 1888 and also retained the Irwell Navigation beyond and the link through Hulme Locks to the Bridgewater Canal. Barges regularly worked between the docks and the Bridgewater through Hulme Locks.

The building of the Manchester South & Altrincham Junction Railway to Altrincham involved some straightening of the Bridgewater Canal from Stretford to Altrincham. Later, another diversion of the Bridgewater Canal became necessary at Trafford Park to permit the construction of the Cheshire Line Committee Railway there.

The Manchester Bolton & Bury Canal Company's decision to make a railway from Salford to Bolton led to the removal of Lock 4 of their canal north to near Lock 5. Later, the Lancashire & Yorkshire Railway, the successor to the Manchester & Bolton Railway, widened their railway lines there, moving locks 4 and 5 and altering the line of the canal again.

A twentieth-century improvement involved the Leeds & Liverpool Canal at Burnley, where the aqueduct was replaced (in 1927) to allow for road widening. Other improvements in this area included bridge widening and replacement, especially in urban districts. This was also a time of consolidation and closure as traffic declined. Closures of waterways became a matter of course. The London & North Eastern Railway, which owned the Ashton and Peak Forest, abandoned the Stockport Canal and the Peak Forest Tramway. The London, Midland & Scottish Railway closed the Huddersfield Narrow Canal from 1944. Traffic on the privately-owned Rochdale was also in terminal decline by the 1940s. Their other canal, the Manchester Bolton & Bury was similarly affected, with traffic principally confined to the Bury end or the Salford end.

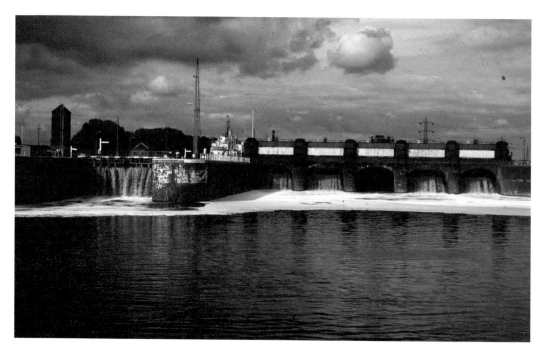

Irlam Locks, Manchester Ship Canal

Two views of Irlam Locks show the approach from either side. In the upper view, the lock and weir are seen. It is a feature of the ship canal locks to place the weir at a midway point along the length of the lock. In the upper view, we look from the Manchester side to the locks, with MV *Salford* in the locks and the tall blast furnace of the Irlam Steelworks visible in the background. (*RCHS Chris Bartlett Collection 82176, M. Oxley Collection 86165*)

Partington Coaling Basin, Manchester Ship Canal
Partington had coaling facilities that initially supplied ships with coal for their journey but were later adapted for loading coal brought by rail from various collieries. (*RCHS Chris Bartlett Collection 82174*)

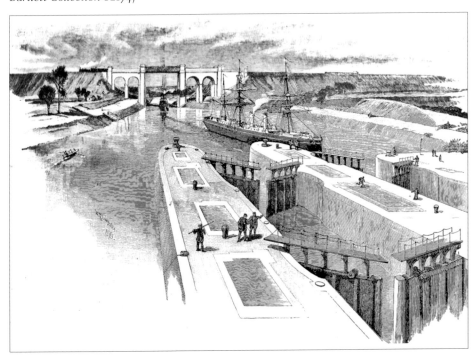

Irlam Locks, Manchester Ship Canal
When the ship canal opened, the *Illustrated London News* printed this engraving of Irlam Locks, which shows ships with tall rigging passing under the railway viaduct. (*RCHS Photograph Collection 42504*)

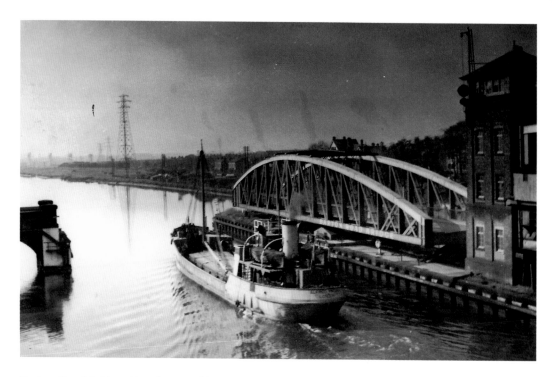

Barton Road Bridge, Manchester Ship Canal
Swing bridges at Barton and Salford. (*RCHS Hugh Compton Collection 65159*)

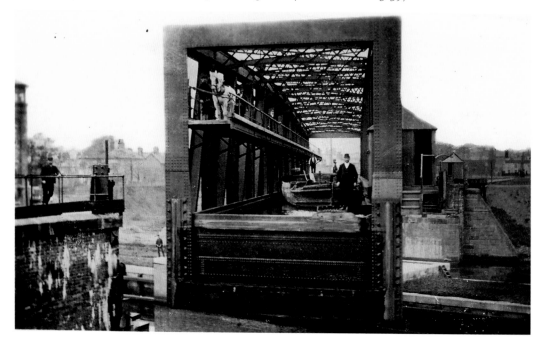

Barton Aqueduct, Bridgewater Canal Crossing Over Ship Canal
Brindley's three-arch aqueduct over the Irwell was replaced by the unique Barton Swing Aqueduct, which is turned to allow craft to pass. (*RCHS Post Card Collection 95453*)

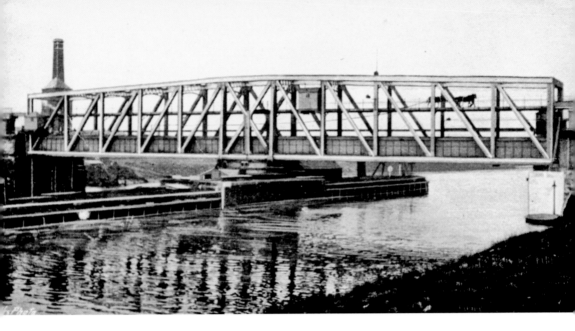

Barton Aqueduct, Bridgewater Canal, Complete with Towing Path
Barges were towed by horses along the aqueduct towpath, which was fixed high on the structure above the waterway. This path remained in place until the 1980s, but has now been removed. (*Above: Heartland Press Collection 780742. Below: RCHS K. Gardiner Collection 67109*)

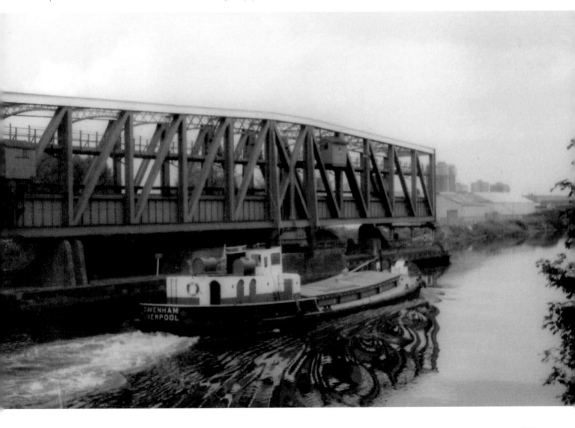

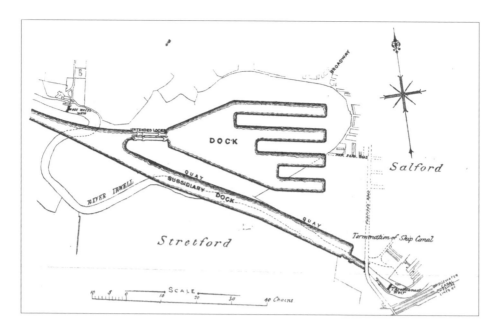

Intended Terminus of Ship Canal at Salford, 1882

The Manchester Ship Canal terminus was first intended as a series of docks served by a pair of entrance locks. The scheme led to the abandonment of the Mersey & Irwell Navigation mode wheel locks but retained Throstle Nest Lock to access the Irwell Navigation. (*Heartland Press 781515*)

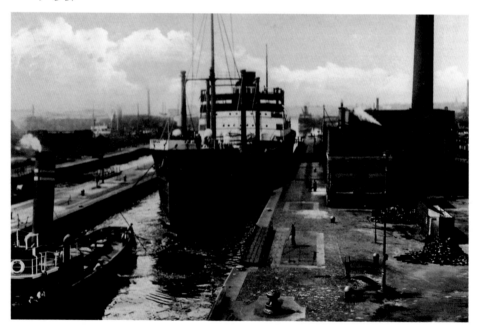

Mode Wheel Locks, Manchester Ship Canal

Mode Wheel Lock replaced the nearby Mersey & Irwell Navigation lock and became the last and highest lock in the navigation. From there, the ship canal continued onto various docks and wharves placed on both sides of the navigation. (*RCHS Postcard Collection 96604*)

Manchester Docks, Salford, Manchester Ship Canal

The terminus of the Manchester Ship Canal was at first concentrated around a group of docks placed in Salford and Manchester. No. 9, the largest, was constructed later. Queen Victoria had formerly opened the ship canal during her reign and it became the duty of her son, King Edward VII, to officially open Dock 9 in 1905. The largest group of docks were those (Nos 5–9) in Salford (*above*), while the River Irwell passes through this complex to the right. The lower image is reproduced from the *Illustrated London News* and shows the Salford Docks as built (1894). Beyond the swing bridge on the right-hand side and the Manchester side were the Pomona Docks (Nos 1–4). (*Above: RCHS Postcard Collection 96605. Below: RCHS Photograph Collection 42508*)

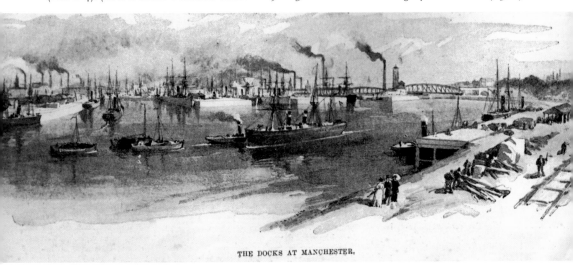

THE DOCKS AT MANCHESTER.

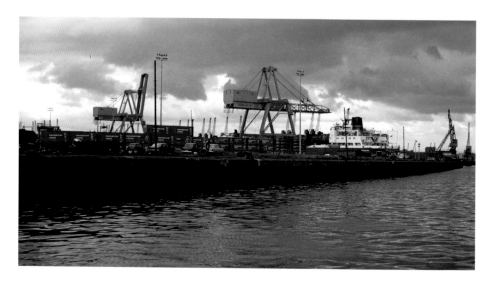

Manchester Docks, Manchester Ship Canal, 1972
Containerisation had an important impact on freight transport during the 1960s, and for a time the Manchester Ship Canal was able to handle container ships in Manchester, but as ship sizes increased, such trade was lost and has only recently returned to serve a new container facility at Irlam. (*RCHS M. Oxley Collection 86176*)

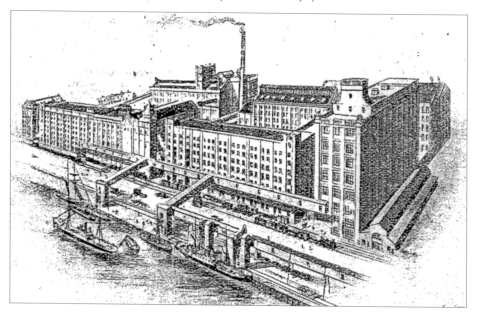

Manchester Docks, Salford, Manchester Ship Canal, 1918
The land around the Manchester & Salford Docks attracted development for a wide range of industries, but principally oil refiners, oil importers, corn millers, flour millers and timber importers. There was also a separate entity adjacent to the Manchester Docks known as the Trafford Park Estate. The Ship Canal and the Ship Canal Railway served all these places and there were also rail links to the British rail network. The Cooperative Wholesalers Sun Mills were part of Manchester Docks, and were served by both shipping and the Manchester Ship Canal Railway. (*Heartland Press Collection 781576*)

Top Lock, Poolstock, Leeds & Liverpool Canal, Leigh Branch
Poolstock Locks are now a pair of locks. They were created following mining subsidence when the level of the canal through Abram and Bickershaw was seriously affected. Three locks that had existed on the canal gradually became level channels. The alteration of levels led to the making first of Poolstock Top Lock and then a second below it. (*Ray Shill 770104*)

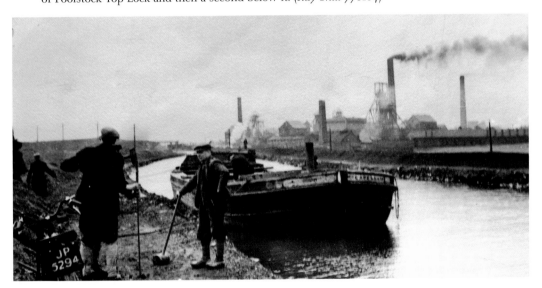

Bickershaw Colliery, Leeds & Liverpool Canal, Leigh Branch
Bickershaw Colliery had shafts near Plank Lane, where mining subsidence affected canal levels, requiring reconstruction of the canal and towpath from time to time and the building up of the banks to maintain the navigation. This image was taken in 1948 when the Docks and Inland Waterways Executive (DIWE) had taken charge of the Leeds & Liverpool Canal. (*Heartland Press Collection 770656*)

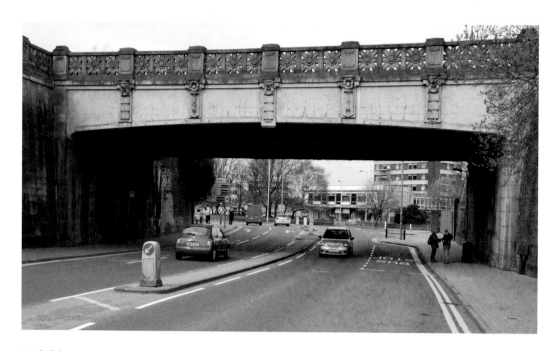

Yorkshire Street Aqueduct, Burnley, Leeds & Liverpool Canal

The original aqueduct that carried the canal over Yorkshire Street was completed, along with the embankment, during 1797. The increasing traffic along Yorkshire Street led to the boring of two pedestrian tunnels either side of the existing roadway in 1890. Between 1926 and 1927 the original road tunnel and pedestrian tunnels were replaced by a new and taller steel aqueduct faced with stone. (*Ray Shill 769002 & 769003*)

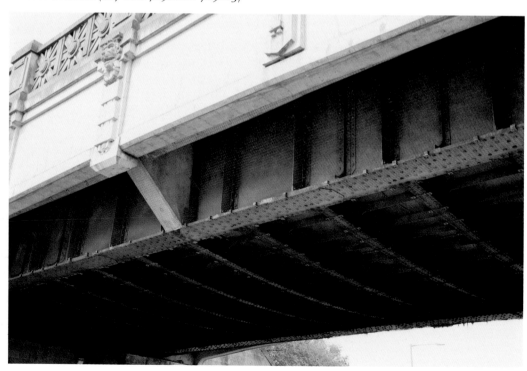

Chapter Seven
Nationalisation, Restoration
& Trusts

Pomona Lock, Manchester Bolton & Bury Restoration and Ashton Canal Restoration

Any study of Manchester waterways is complicated by the fact that part of the canal network remained in private ownership. The Bridgewater Canal, Manchester Ship Canal and the Rochdale Canal remained in independent hands. Only the former railway canals and the Leeds & Liverpool were transferred to the DIWE, and eventually into the control of British Waterways. The Leeds & Liverpool was transferred into DIWE ownership from Vesting Day (1 January 1948), while railway canals moved across within a year. These were: the Ashton Canal; Manchester Bolton & Bury Canal; and Peak Forest Canal.

Trading on these northern waterways declined dramatically. For the Ashton Canal, and the part of the Peak Forest Canal south of Marple, decline led to dereliction, with sections of the canal placed in pipes.

During 1968, the Inland Waterways Protection Society made a start on restoring Bugsworth Basin at the end of the Peak Forest Canal, and that action was followed by other schemes planned on a much grander scale. By 1970 there was a growing need for pleasure boating and this led to a campaign to save the Ashton and Peak Forest canals in their entirety. Waterways enthusiasts and restoration volunteers frequently came into conflict with British Waterways at this time, but gradually they persuaded the British Waterways Board to allow restoration of these canals. In their wake came the countrywide restoration movement.

The Ashton and Lower Peak Forest and the Rochdale Nine formed part of the Cheshire Ring – a boaters' cruising ring that also included the Trent & Mersey, Macclesfield, and Bridgewater canals. It led to a greater use of pleasure boating at a time when commercial carrying was in terminal decline.

Once the Ashton and Peak Forest canals were open again (1974), encouragement was given to restoration of the Rochdale. This scheme faced an uphill struggle as motorways and modern roads came to cross the canals on the level and stretches were filled in or built upon. The canal also remained in private ownership, which had mixed benefits for restoration.

Within the Greater Manchester area, the Rochdale required two major diversions to restore the navigation in Greater Manchester. The first was for the M60, where the canal was channelled into a tunnel under the motorway, while the towpath was diverted along a bridge over it.

Another diversion was required south of Blue Pits, where Lock 53 ceased to function as a lock when the bed was built up and diverted eastwards to take the canal onto a new route under the M62 waterway and a new lock chamber south of the M62. A third new short section was also created near Rochdale. A novel feature of this waterway was Grimshaw Lane Vertical Lift Bridge, which enabled boats to pass Grimshaw Lane, Oldham, where the original bridge had been replaced by road crossing at towpath level.

Motorway construction affected other waterways in this region. The Leeds & Liverpool Canal was diverted into a new channel east of Hapton to make way for the M65.

While the Peak Forest Canal had reopened for most of its length, the part at Bugsworth (Buxworth) Basin remained closed. A subject of a long-term restoration project, this basin closed since the 1920s was finally opened for boaters' use in 2003.

The Manchester Bolton & Bury Canal Society was formed (in 1987) with the hope of restoring the canal to Bolton and Bury, even though it had partly been closed by a breach, and parts had become filled in and covered over. A section was restored in Manchester in 2008 and a new bridge was provided at Nob End in 2012.

Peel Holdings control both the Bridgewater and Manchester Ship canals. The Bridgewater between Preston Brook and Manchester is popular with boaters cruising the Cheshire Ring, while the Leigh Branch has a certain use for boaters passing to and from the Leeds & Liverpool Canal. They also provided a new lock at Pomona to allow craft onto the Manchester Ship Canal and the Upper Reach of the River Irwell. Peel Holdings are also improving navigation to the Ship Canal at Salford.

Salford and Pomona Docks closed in 1982 and those at Salford were sold to Salford Council in 1984, which since that time have commenced a gradual and systematic redevelopment of the former docks, including new residential and commercial properties that are linked by new roads and the Metrolink (the name for Transport for Greater Manchester's tram network).

Peel Holdings do have plans to reintroduce ships to a new port at Salford, which will be tri-modal, served by rail, roads and shipping. It is the main intention of the project called Atlantic Gateway that will see points on the ship canal served by regular barge traffic.

Plank Lane Lift Bridge, Leeds & Liverpool Canal, Leigh Branch, 1998
There was a standard road overbridge that originally carried the canal over the tail of the lock. With mining subsidence, the level on either side of Plank Lane Lock became equal and the overbridge was replaced during 1910 by a swing bridge. This swing was renewed twice, but with increasing road usage, British Waterways decided to replace the Swing Bridge with a lift bridge in 1977. (*Ray Shill, 770651*)

Rochdale Canal, M62 Deviation

In order to return navigation to the Rochdale Canal, realignment and deviation was required at several points. Two major alterations were required to pass the M62, near Rochdale, and the M60 near Oldham. The work for the M62 deviation required the moving of Lock 53 to a new site and the making of a new channel. The M62 work also covered the junction with the Haywood Branch. (*Ray Shill, 834574 & 834565*)

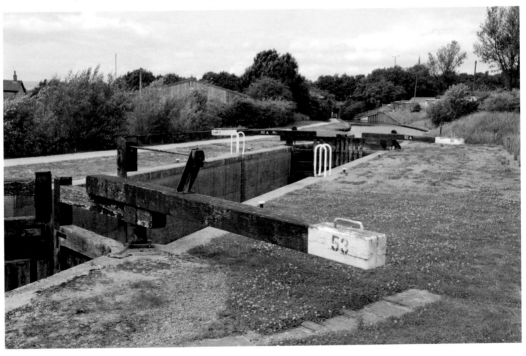

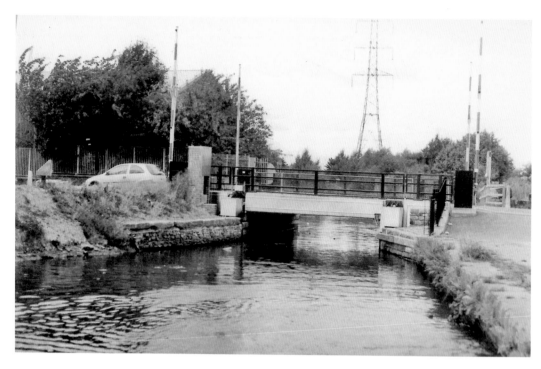

Lift Bridge, Grimshaw Lane, Near Middleton, Rochdale Canal
With the restoration of the Rochdale Canal near Middleton, the former road bridge across the canal had been removed. The chosen bridge replacement was a lift bridge raised vertically. (*Ray Shill 834404 & 834405*)

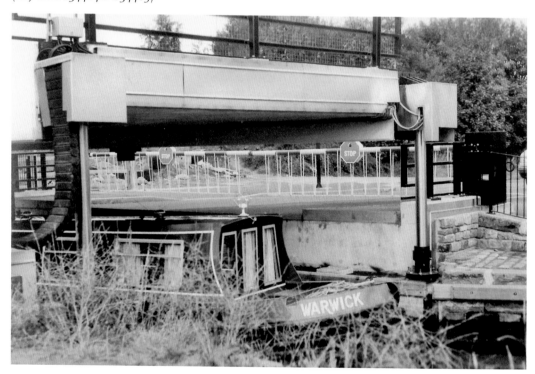

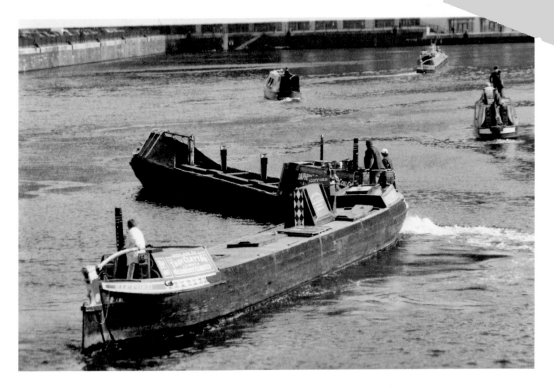

Salford Docks, Manchester Ship Canal, 1998
The decline of shipping traffic into the Port of Manchester led to an increase in leisure traffic using the docks. In August 1998, Salford Docks were used to host the annual Inland Waterways Festival, where narrowboats were able to turn and circle in the vast dock area. (*Ray Shill 781611*)

Pomona Lock
This new lock provides a link between the Ship Canal, Pomona No. 3 Dock, and the Bridgewater Canal. (*Ray Shill 785151*)

Transformations Around Castlefields, Manchester

Castlefields Basin, the terminus of the Bridgewater Canal, has been changed with new developments and two old warehouses, the Merchants and the Middle, converted for new uses. In the upper image, the canal side around the Merchants Warehouse is shown, while in the lower image the canal side around the Grocers' Warehouse is seen. (*Ray Shill 784784 & 784815*)

Ontario Basin & Erie Basin, Salford Docks

Salford Docks have been transformed with leisure and commercial facilities. The former docks have been enclosed and linked by a pair of new canal channels. Former Dock 8, now known as Ontario Basin (*above*), forms the link by these new channels to Erie Basin (*below*) and St Peters Basin. (*Ray Shill 781651 & 781658*)

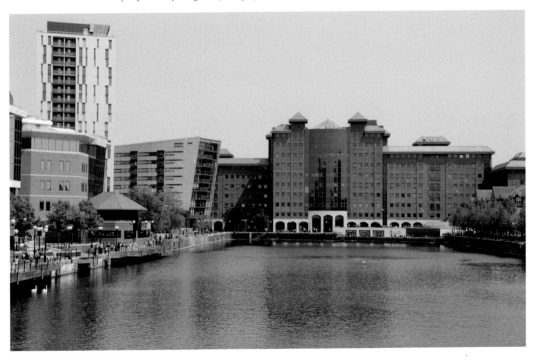

New Tunnel, Manchester Bolton & Bury Canal, 2013
The old staircase lock was removed and modern roads have since covered the lock site. Restoration of the route began with the construction of a new tunnel under the road and a deep lock. (*Ray Shill 762010 & 762014*)

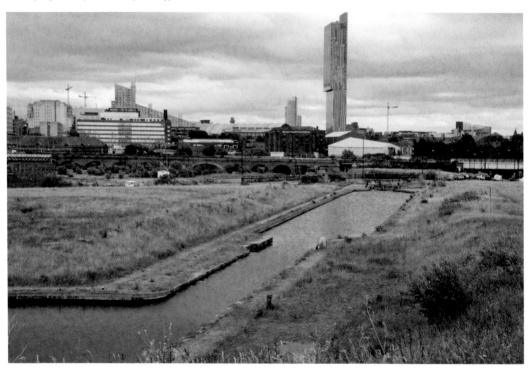

Manchester Skyline and the Manchester Bolton & Bury Canal, 2013
The original third lock, now the second lock of the restored navigation, is surrounded by a modern wasteland, awaiting any whim or plans developers might hold. In the background is the modern skyline of Manchester, a scene that has changed much in the last twenty years. (*Ray Shill 762017*)

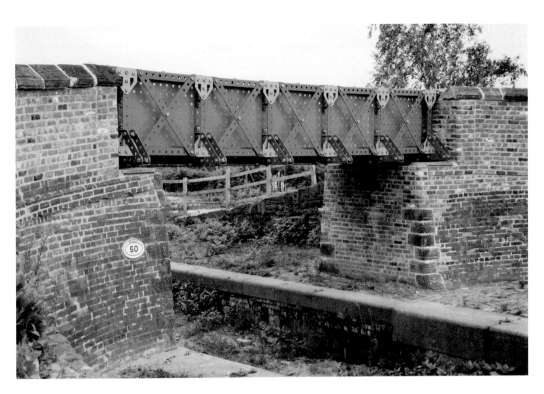

Meccano Bridge, Nob End, and Staircase Locks, Manchester Bolton & Bury Canal, 2013
A new and novel footbridge was constructed across the entrance to the top lock at Nob End in 2012. Restoring these two sets of staircase locks will perhaps be a more simple challenge compared to other parts of the canal that require restoration. (*Above: Ray Shill 762931. Below: 762927*)

Notable Structures on North West Canals

Grid References are quoted for locations, and for tunnels and embankments/reservoir feeders from West to East (W–E) or North to South (N–S)

*English Heritage Listed Structures: 1, 2, 2**

Ashton Canal

Piccadilly–Ashton

Paradise Wharf	SJ849981
Manchester Sheffield & Lincolnshire Railway	
Warehouse	SJ848979
Store Street Aqueduct	SJ850981 (2*)
Ancoats Locks 1	SJ852981 (2)
Ancoats Locks 2	SJ853982 (2)
Ancoats Locks 3	SJ854983 (2)
Islington Basin (N–S)	SJ853982–
	SJ855982
Soho Arm (N–S)	SJ853982–
	SJ855980
Medlock Aqueduct	SJ864987
Pottery Arm	SJ865987
Beswick Locks 4 & 5	
(W–E)	SJ865987–
	SJ866987
Lock 6	SJ868987 (2)
Bradford Colliery Branch	
(above Lock 6)	SJ868987
Lock 7	SJ869988 (2)
Lock 8	SJ876984 (2)
Lock 9	SJ879982 (2)
Lock 10	SJ881982 (2)
Stockport Branch Junction	
Towpath Bridge	SJ882981 (2)
Lock 11	SJ883981 (2)
Lock 12	SJ884981 (2)
Lock 13	SJ886981 (2)
Lock 14	SJ889980 (2)
Lock 15	SJ890980 (2)
Lock 16	SJ891979
Fairfield Locks 17 & 18	
(W–E)	SJ989978–
	SJ900979
Portland Basin and	
Warehouse	SJ934985
Asda Tunnel	SJ986940
Old wharf, Ashton	SJ941988

Beat Bank (not finished)

Dukinfield Branch to Peak Forest

Dukinfield Aqueduct (over River Tame)	
	SJ935985 (2)

Fairbottom Branch

Valley Aqueduct	SD927013

Hollinwood Branch

Waterhouses Tunnel	SD921007
Waterhouses Aqueduct (over	
River Medlock)	SD921008 (2)
Daisy Nook Iron	
Aqueduct	SD919012
Lock 1–4 (including	
staircase 2/3)	SD920010

Junction with Fairbottom
 Branch SD919010
Lock 5 SD906025
Lock 6 SD907026
Lock 7 (top lock) SD907032
Hollinwood Top Wharf SD905027
Reservoir (site) SD910030

Stockport Branch
Gorton Aqueduct SJ890969
Stockport Wharf SJ890905

Bridgewater Canal

Main Line
Barsbank Aqueduct
 (21A) SJ673874 (2)
Whitbarrow Underbridge
 (22A) SJ682873 (2)
Grantham's Bridge SJ701874 (2)
Burford Lane Underbridge
 (25A) SJ704873 (2)
Warehouse (near Burford Lane)
 SJ706872
Dunham Embankment
 (W–E) SJ720866–
 SJ735880
Bollington Underbridge
 (26A) SJ727871
River Bollin Aqueduct SJ728874 (2)
Dunham Woodhouse Underbridge
 (26B) SJ731877
Broadheath Warehouse SJ765890
Barfoot Aqueduct SJ795933 (2)
Cut Hole Aqueduct (Hawthorn
 Road) SJ 796937
Raised Towpath SJ795933–
 SJ792896
Water Meeting Junction SJ796955
Chester Road Viaduct, Castlefield
 Basin SJ833975
Grocers's Warehouse, Castlefield
 Basin SJ833975
Merchants Warehouse, castlefield
 Basin SJ831975

Middle Warehouse, Castlefield
 Basin SJ831874
Overflow Weir, Giants Basin,
 Castlefield SJ830977
Chat Moss Branch
Branch (N–S) SJ752999–
 SJ752995

Hulme Locks
Hulme lock 1–3 SJ826974 (2)

Leigh Branch
Astley Green Colliery
 Wharf SJ703998
Barton Swing Aqueduct (site of Barton
 Aqueduct Over Irwell)
 SD766977
Barton Lane Underbridge
 (46A) SJ766977
Boothstown Basin SD727004
Packet House, Worsley SD748004
Worsley Delph Basin SD748005
East Lancs Road Bridge SJ690994
Marsland Green Wharf SJ684994

Pomona Docks
Pomona Lock SJ820967

Fletcher's Canal
Lock SD792035

Irwell and Mersey Navigation

River Irwell
Barton Lock (site) SJ767977
Calamanco Lock (site) SJ755955
Holme Bridge Lock (site) SJ750959
Mode Wheel Lock (site) SJ796982
Stickings Lock (site) SJ746984
Throstle Nest Lock (site) SJ810966
Victoria and Albert
 Warehouses SJ831982

River Mersey

Butchersfield Lock	SJ678891
Millbank (Hollins Ferry)	
Lock (site)	SJ699907
Sandywarps Lock (site)	SJ720931

Lancaster

South Lancaster

Aqueduct (Lancashire Union	
Railway)	SD587103
Red House Aqueduct (River Douglas)	
Adlington	SD599124 (2)
Aqueduct (River Yarrow)	
Chorley	SD597174
Whittle Hills Tunnel	SD585212
Walton Summit Basin	SD568254

Johnson's Hillock Branch and Locks

Johnson Hillock Locks (64–58)	
(N–S)	596214–
	SD590206 (2)

Leeds & Liverpool Canal

Main Line

Wigan Top Lock (65)	SD607067
Roddlesworth Aqueduct,	
Fenniscowles	SD645245
Ewood Aqueduct,	
Blackburn	SD677265 (2)
Blackburn Locks	
(57–52)	SD677266–
	SD683272
Eanam Wharf, Blackburn	SD688282
Rishton Reservoir Dam	SD715302
Aspen Colliery and	
Coke Works	SD735285
Church Wharf and	
Warehouse	SD740284
Enfield Wharf, Clayton	
Le Moors	SD748305
Hapton deviation for M65	
Motorway	SD800319
Rose Grove Wharf	SD814326

Gannow Tunnel (W–E)	SD824325–
	SD827330
M65 Aqueduct Burnley	SD832329
Burnley Wharf	SD838323
Finsley Gate Maintenance	
Yard	SD843319
Burnley Embankment	
(N–S)	SD846332–
	SD843321
Yorkshire Street Aqueduct,	
Burnley	SD845325
River Don Aqueduct,	
Burnley	SD845335

Leigh Branch

Leigh Warehouse	SJ654998
Aqueduct (Leigh)	SD649000
Plank Lane Lift Bridge (8)	
and lock site	SD631996
Dover Bridge and	
Locks (site)	SD607007
Poolstock Lock (2)	SD579043
Poolstock Lock (1)	SD579045

Manchester Bolton & Bury Canal

Main Line

River Locks (1–2)	SJ980830
Margaret Fletcher Tunnel	SJ981830
Lock 3	SJ982828
No 1 Tunnel (site of)	SJ982828
No 2 Tunnel (Manchester and Bolton	
Railway)	SJ983827
Lock 4 (original pre-1836 removed to	
make railway)	SJ983827
Locks 4/5 pre-1894 moved to railway	
widening	SJ983826
Locks 4 and 5 post-1894	SJ984826
Lock 6	SJ984825
Lumbs Aqueduct 28	SD797034
Clifton Aqueduct 32 (over	
River Irwell)	SD793035 (2)
Rhodes Lock 7	SD777041
Lock 8 and 9, Giants Seat	SD773046

Ringley Locks (10, 11) SD763055
Prestolee Aqueduct SD752063 (2)
Lock 12–14 Triple
 Staircase SD752064
Lock 15–17 Triple
 Staircase SD753065
Meccano Bridge SD753065

Bolton Branch

Hall Lane Aqueduct 54 SD744072
Foggs Aqueduct 56 (site) SD743075
Damside (over River Tonge)
 58 (site) SD733081
Church Wharf (site) SD722094

Bury Branch

Feeder from Elton reservoir
 (N–S) SD792097–
 SD792094
Daisyfield Viaduct SD795103
Brooks Mount Aqueduct (Walshaw
 Brook) (site) SD795105
Warehouse sites SD795107
No. 1 Tunnel & No. 2
 Tunnel SD796110
Intake feeder from Irwell SD796112

Feeder

Inlet to Reservoir SD789097
Burrs Aqueduct SD798127
Intake from Irwell SD796131

Manchester and Salford Junction Canal

Bottom Lock SJ837977

Manchester Ship Canal

Barton Swing Bridge SJ767976
Cadishead Viaduct SJ921717
Irlam Lock SJ941727
Irlam Viaduct SJ937726
Mode Wheel lock SJ975798

Pomona Docks 1–4 (N–S) SJ969820–
 SJ967818
Salford Docks 6–9 (N–S) SJ975801–
 SJ968802

Peak Forest Canal

Main Line

Railway Bridge SJ935983
Lift bridge SJ935979
Railway Bridge SJ934975
Turnover Bridge 6 SJ943951
Hyde wharf SJ943950
Turnover Bridge (Captain
 Clarke's) 7 SJ942936
Apethorn Aqueduct SJ941933
Woodley Tunnel (N–S) (Portals
 Listed) SJ935924–
 SJ935921 (2)
Hatherlow Aqueduct
 (Green Lane) SJ936904
Chadkirk Aqueduct
 (Chadkirk Rd) SJ937903
Hyde Bank Tunnel (W–E) SJ947903–
 SJ949902
Marple Aqueduct
 (River Goyt) SJ955901 (1)
Marple Locks 1–16 SJ958900–
 SJ961884
Samual Oldnow's
 Warehouse SJ963889
Possett Bridge (18) SJ961886 (2)
Marple Junction SJ962882
Turf Lee Lift Bridge SJ968863
Strines Aqueduct SJ969861 (2)
Wood End Lift Bridge 24 SJ976856
Higgins Clough Swing
 Bridge 25 SJ977853
Carr Swing Bridge 30 SK001845
Furness Vale Aqueduct SK007836
Bridgemont Aqueduct
 (horse tunnel) SK013822
Bugsworth Basin SK023820

Whaley Bridge Branch

Basin and Warehouse SK011816 (2)
Toddbrook Reservoir Dam
 (N–S) SK006812–
 SK007810

Rochdale

Main Line

Dukes Lock 92	SJ831975 (2)
Deansgate (Gaythorn) Tunnel	SJ833975
Deansgate Tunnel Lock 91	SJ834975 (2)
Albion Mills Lock 90	SJ835975 (2)
Tib Lock 89	SJ837977 (2)
Oxford Street Lock 88	SJ840976 (2)
Princes Street Lock 87	SJ842977 (2)
Chorlton Street Lock 86	SJ844979 (2)
Piccadilly Lock 85	SJ846980 (2)
Dale Street Lock 84	SJ847981 (2)
Rochdale Canal Offices	SJ847982 (2)
Dale Street, Warehouse	SJ847982 (2)
Brownsfield Lock 83	SJ848983 (2)
Ancoats Lane Lock 82	SJ850985 (2)
Butlers Lane Lock 81	SJ857991
Coalpit Lane (Lower, Middle & Higher) 80–78	SJ858992–SJ861994

Anthony's Lock 77	SJ865996
Locks (Slater's Lower Failsworth Top) 76–65	SJ866998–SD897017
M60 Tunnel 76B and Towpath Bridge	SD896032
Grimshaw Lane Vertical Lift Bridge 75A	SD890048
Kay Lane Lock 64	SD890050
River Irk Aqueduct	SD892063
Walkmill Lock 63	SD891065
Coney Green Lock 62	SD888065
Scowcroft Lock 61	SD888067
Boardshaw Lock 60	SD885071
Laneside (Slattocks) Locks (1–6) (N–S)	SD885085–SD885077
Blue Pits New Lock 53	SD883097
Blue Pits Old Lock 53	SD882101 (2)
Blue Pits Middle Lock 52	SD882102 (2)
Blue Pits Highest Lock 51	SD883107
Edinburgh Way Tunnel 62B	SD891116

Heywood Branch

Terminus Basin (site) SD860102